IMAGES
of America

NAPLES
1940s to 1970s

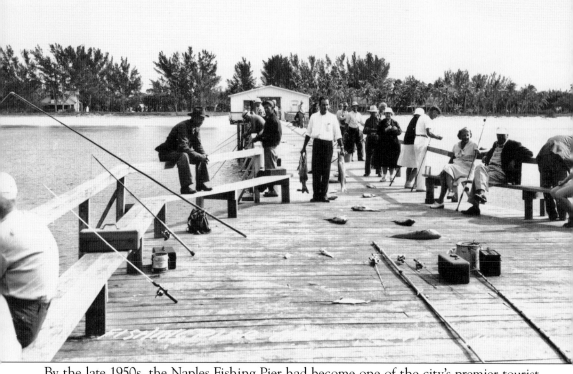

By the late 1950s, the Naples Fishing Pier had become one of the city's premier tourist attractions, and an editorial in the *Collier County News* advised, "Visiting Naples and not taking a walk on the pier is like going to Niagara and not seeing the Falls. Anything that swims is highly likely to be caught here." First built in 1888, and later rebuilt after a series of hurricanes, the pier once offered the only access to the tiny resort town perched on the edge of the Everglades. With the arrival of train service in 1927 and the opening of the Tamiami Trail in 1928, the pier lost its importance as a dock and became a popular place to fish. During the 1950s, when this pre–Hurricane Donna photograph was taken, notable catches were reported weekly in the *Collier County News*, and a February 1950 fishing column noted, "This week, pier fishermen hooked everything from a 250-pound sea turtle to a gold bracelet." (Courtesy of Nina Heald Webber.)

On the Cover: The first Swamp Buggy Day was held on November 12, 1949. The day-long celebration of the strange swamp-striding machines, invented in Naples by Ed Frank, included races and a parade down Fifth Avenue South led by city officials. Pictured in the lead car, with the northwest corner of Four Corners visible in the background, are, from left to right, driver Wink Clack, Councilmen Pitt Orick and Claude Storter, City Manager Fred Lowdermilk, and Councilmen Rex Lehman and Lige Bowling. (Courtesy of the Florida State Archives.)

IMAGES
of America

NAPLES
1940s to 1970s

Lynne Howard Frazer

ARCADIA
PUBLISHING

Published by Arcadia Publishing
Charleston, South Carolina

Printed in the United States of America

Library of Congress Catalog Card Number: 2005936469

For all general information contact Arcadia Publishing at:
Telephone 843-853-2070
Fax 843-853-0044
E-mail sales@arcadiapublishing.com
For customer service and orders:
Toll-Free 1-888-313-2665

Visit us on the Internet at www.arcadiapublishing.com

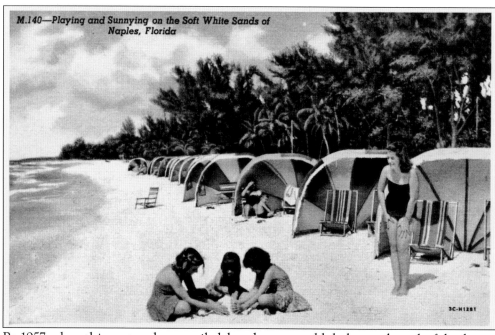

By 1957, when this postcard was mailed, beachgoers could shelter under colorful cabanas located just north of the pier. Each year, the pristine beach attracted an increasing number of visitors—and new residents—and Harold Jester, president of the Naples Motel Association, noted prophetically in 1956, "After three or four years, many visitors decide to build here, and it happens more and more each passing year."

CONTENTS

Acknowledgments 6

Introduction 7

1. Diamond-in-the-Rough 9

2. "Stop and Stay for Awhile" 21

3. Good Food, Good Times 33

4. Fun-in-the-Sun 43

5. The Winds of Change 69

6. "It's Great to Live in Naples!" 89

7. Coming of Age 105

ACKNOWLEDGMENTS

This book would not have been possible without the support of two very special people—Mrs. Nina Heald Webber and Gerry Johnson—who generously provided most of the images for this book. Mrs. Webber, who shared many of her images for the first Naples book, again allowed me access to her extensive vintage postcard collection. Gerry Johnson, *Naples Daily News* librarian, allowed me unprecedented access to the archives of the *Collier County News* (forerunner of the *Naples Daily News*), where I found extraordinary images of a long-lost Naples. Gerry, thank you so much for letting me dig deep into the files and for sharing your vast knowledge of Naples and Collier County history.

I would also like to thank the excellent staff at Naples Print Source, including Len Rose, Greta Masters, and Ed Minor for their always cheerful and prompt help, and Kevin Yablonowski for his expert digitizing of the images in this book.

Special thanks also to Nancy Evans, Jan Gregory Frazer, Lori Keller Stuber, the Naples Art Association, the Naples Players, and the Collier Mosquito Control District for sharing images highlighting the development and social history of Naples.

I also want to thank my parents, Joseph and Shirley Howard, for teaching me a love of history and books, and my mother-in-law, Jan Gregory Frazer, also a writer, for always believing in me. Of course, this book would not have possible without the unwavering support of my husband, Russell G. Frazer. Thank you—for everything.

The images in this book are from the collection of the *Naples Daily News*, unless otherwise noted.

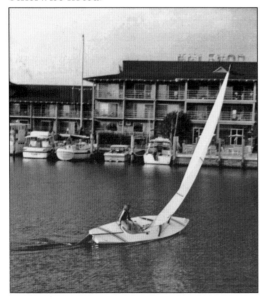

Russell Frazer sails his super-sunfish, *Challenger*, in front of the Cove Inn, c. 1975. The motel and "yachtel" opened in 1964 and was designed in the post–Hurricane Donna "Neapolynesian" style popularized by architect William Zimmerman. The Cove Inn later became one of the first successful condominium hotels in Florida. (Courtesy of Jan Gregory Frazer.)

INTRODUCTION

"Tourists are to Naples what orange juice is to Florida," claimed a 1978 *Naples Daily News* "Visitors Edition" story. From the start, the once-remote and rustic resort, founded in 1885 as a place where "invalids can escape the chilling blasts of winter," depended on tourism. Accessible only by water, however, the town perched on the edge of the Everglades remained primarily a winter retreat for the rich until train service arrived in 1927. A year later, with the opening of the Tamiami Trail, the first road through the Everglades, Naples was finally accessible to a new traveling public—and to developers.

The stock market crash of 1929 and the ensuing Depression stalled development, however, and Naples languished, little more than a "bend in the road" until after World War II. As Americans began to travel again, sun-seekers headed south and rediscovered the endless white beach and phenomenal fishing found in the one-stoplight town.

By 1952, the city's three trailer parks and handful of hotels couldn't keep up with the increasing number of winter visitors, and an editorial in the *Collier County News* implored residents to help: "A good example of the hospitality of Naples is the fact that Mayor Roy Smith has taken travelers into his own home on nights when the situation has been desperate. Have you got an extra room in your house? Notify the Chamber of Commerce if you would like to do some weary motorist a good turn."

Many winter visitors returned to buy property, and by the early 1950s, the backwater village was becoming a boomtown. In 1949, the year Naples became a city, the first dredge-and-fill operation, Aqualane Shores, began to transform "useless" swampland into waterfront home sites. The inspired idea of creating man-made canals and multiple waterfront lots spurred similar developments, including Port Royal, the Moorings, and Royal Harbor, "Where every backyard is bay front."

From mobile homes to mansions, property was available in every price range. "Be independent by owning your own piece of Florida, the land of forever summer," implored a 1952 advertisement for Naples Park. Options that year included a Naples Park lot for $10 down and $10 a month for a $239 lot, and a luxurious, waterfront, three-bedroom "Bermudian" residence in Port Royal for $45,000.

In addition to beautiful beaches and balmy weather, visitors soon had another reason to come to Naples—Caribbean Gardens. Julius "Junkie" Fleischmann, a wealthy entrepreneur and philanthropist, opened the gardens in 1954, and by the late 1950s, the exotic tropical plants and performing "Duck Vaudevillians" had become a premier tourist attraction. The piano-playing ducks performed on the *Ed Sullivan Show* and throughout Europe, and a *Collier County News* writer credited the gardens as "one of the primary generators of traffic into Greater Naples. It is estimated (from nationally-conducted surveys) that 12,000 people come to Naples yearly just to see the birds and to stroll along the shaded paths."

On September 10, 1960, Hurricane Donna stormed through Naples, wreaking havoc on the developing city. An influx of insurance money, combined with tightened zoning and building regulations, spurred the rebuilding of what the chamber of commerce called "a more beautiful Naples." Many new buildings, including the Cove Inn, the

pavilions at both the Pier and Lowdermilk Park, the municipal airport—even the new Ford dealership—were all built in what was affectionately dubbed the "Neapolynesian" style. A 1964 editorial in the *Collier County News* noted, "Everywhere you look, there's something new. It is hard to go down any street in the Naples area and not see something being built."

Development spread to the far reaches of Collier County in 1962 when the Gulf American Land Corporation began work on its newest mega-development, Golden Gate, which included the nearly eight-square-mile city of Golden Gate, the "City of the Future," and more than 100,000 acres in eastern Collier County called Golden Gate Estates. Marketing enticements included free gasoline, trading stamps, Florida oranges, fishing trips, tours of Naples, lunch at a local restaurant, and sightseeing flights over the massive development.

The clever marketing plan worked, and thousands of visitors came to Naples, lured by Gulf American's long list of free goodies. Helen and Bob Baroni, owners of Baroni's Restaurant, were so thrilled with the increased business that they placed a quarter-page advertisement in the March 25, 1962, edition of the *Collier County News* thanking the company for the opportunity to serve "the large numbers of pleasant visitors who have traveled many miles to see and purchase new home sites."

The building boom continued, and by September 1963, a front-page story in the *Collier County News* noted: "Construction is going on at a record pace. Building permits in August amounted to $1,512,955, the largest figure for a single month. In the early 1950s, it took a whole year for that much building to be done. There is a chance the current year's total will hit $10 million."

Although the first beachfront cooperative building, the Bahama Club, opened in 1957, the 36-unit building, "considered the ultimate in luxurious Florida living," remained virtually alone on the beach until the mid-1960s. By 1966, a *Collier County News* editorial asked: "Where will the Naples' high-rise era stop? Five years ago, Gulfshore Boulevard was all but a deserted stretch of sandy beach from the Bahama Club to Doctor's Pass. Today, high-rise co-ops and condos dot the landscape."

That same year, Naples was named one of the top-10 growth cities in Florida by the First Research Corporation, selected for its soundness, rapid growth, and promise for the future. In response, a March 8, 1966, editorial in the *Collier County News* inquired, "With Naples one of the fastest growing communities in the United States, how can even faster growth be accommodated and still conserve the qualities and features of the Naples way of living, which fundamentally are the root cause of Naples' growth?"

It was a question that would be asked again and again. The city continued to struggle with over-crowded roads and the specter of over-development. By 1978, another massive development was underway on the last large beachfront tract, Pelican Bay. *Naples Daily News* editor Thomas Hayer acknowledged the city's growing pains in his special "Visitors Edition" editorial that year, noting: "The visitor who comes to this area year after year sees pretty much the same assets and liabilities, but the momentum for a beautiful future is still there. And we think it will carry us through our major problems and on into the kind of future our pioneer planners and developers had in mind. A place you, dear visitor, will like to visit—and one day make your home."

One

DIAMOND-IN-THE-ROUGH

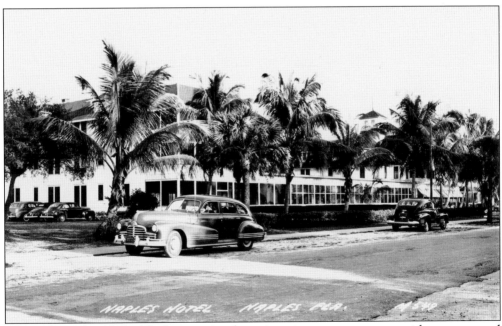

Throughout the 1940s, Naples remained a quiet winter-season resort with a year-round population of less than 2,000 people. During World War II, tourism dropped to an all-time low, and advertisements for the Naples Hotel implored drivers on the Tamiami Trail to stop, enjoy the beach, and "be rested before leaving for Miami." (Courtesy of Nina Heald Webber.)

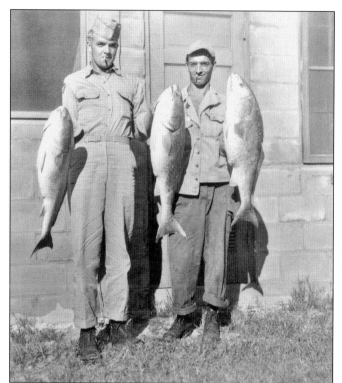

During World War II, the Naples Airdrome was built at the head of Naples Bay to serve as a training base for Army Air Corps fighter pilots. With the Gordon River and the Naples Pier close by, fishing became a popular off-duty activity. In this October 22, 1944, photograph, Cpl. Raymond C. Knapp (left) and Pvt. John Johnson (right) show off their redfish catch while standing outside the Airdrome's armament shop. (Courtesy of the Collier County Museum, Naples, Florida; Raymond C. Knapp Collection.)

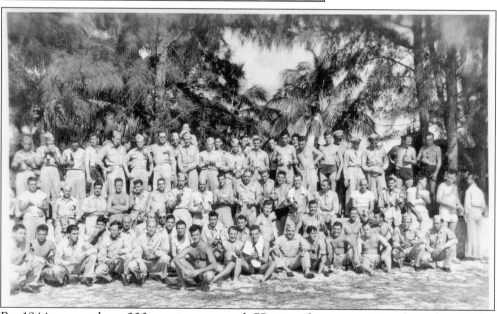

By 1944, more than 200 servicemen and 75 aircraft were stationed at the Naples Airdrome. Squadron "rest and relaxation" activities included this September 23, 1944, party on the Naples beach. Most of the squadron's training missions were flown nearby, primarily over the Gulf of Mexico, where mock attacks were staged against B-17 bombers from the Buckingham Army Air Field near Fort Myers. (Courtesy of the Collier County Museum, Naples, Florida; Raymond C. Knapp Collection.)

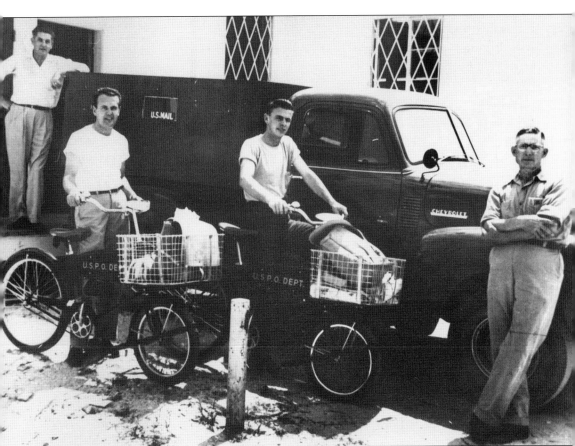

Mail delivery to homes within the city of Naples began on May 6, 1952, with rural delivery for "east Naples, Rosemary Heights and a territory one-and-a-half miles to the north of that suburb" slated for two months later. According to an April 11, 1952, interview with postmaster J. Kenneth Rogers in the *Collier County News*, there were approximately 600 houses in the city eligible for delivery, but the postmaster stressed, "service cannot be given until house numbers and mail boxes are placed by individual homeowners." Rogers added, "Bicycles, delivery bags and sorting equipment have been received. Each delivery man will have to purchase his own uniform." This 1952 photograph, taken at the Third Street South post office, shows, from left to right: J. Kenneth Rogers, postmaster; Bernard Gratton; Bobby Roberts; and John "Pop" Stallons, who drove the parcel post delivery truck.

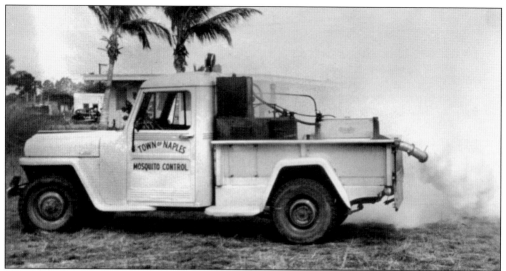

In 1950, the Naples Mosquito Control District was created as an independent special taxing district with a three-member board elected by the Board of County Commissioners. Truck spraying for larvae and adult mosquitoes began in 1951, with personnel and equipment borrowed from the City of Naples. The new district was responsible for spraying six square miles. (Courtesy of Collier Mosquito Control District.)

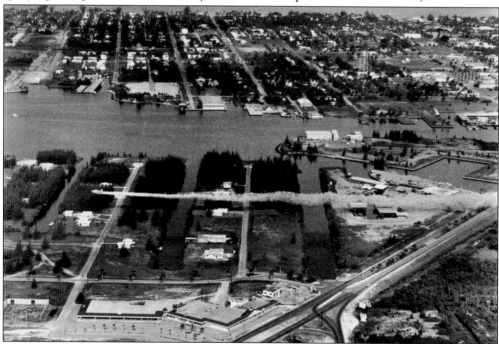

In 1965, with the addition of east and north Naples, the Naples Mosquito Control District was responsible for spraying 98 square miles. The expanded spray area required the addition of a Twin Beech airplane for aerial spraying. By 1976, the newly renamed Collier Mosquito Control District was responsible for spraying 205 square miles, and several DC-3 airplanes joined the fleet. In this c. 1976 photograph, a DC-3 sprays over east Naples.

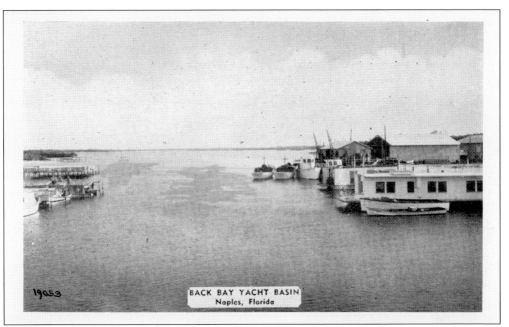

BACK BAY YACHT BASIN
Naples, Florida

In January 1950, the discovery of jumbo shrimp 35 miles offshore from Collier County transformed the quiet docks near the Gordon River bridge, at the head of "Back Bay," into a bustling commercial center—briefly. On February 10, 1950, the *Collier County News* reported: "Hundreds of spectators turned out Wednesday to watch six big trawlers unload more than 29,000 pounds of shrimp, the first catches to be landed, at the Combs fish docks. At .51 cents per pound, the total paid out to the boats was better than $15,000." Just a few weeks later, the newspaper reported the town had lost the bulk of the newly arrived shrimping fleet due to the shallowness of Gordon Pass. (Above courtesy of Nina Heald Webber.)

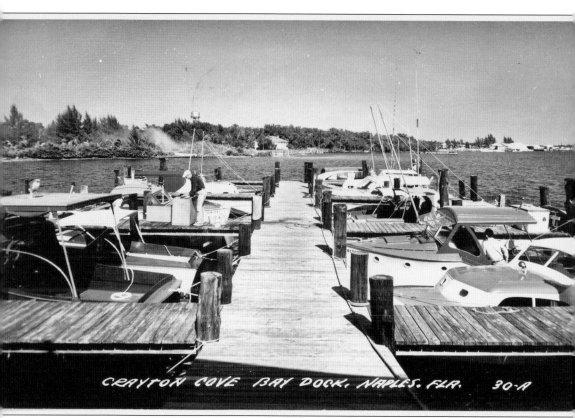

CRAYTON COVE BAY DOCK. NAPLES. FLA. 30-A

In 1948, Benjamin "Benny" Wistar Morris IV began developing the Back Bay dock area at the eastern end of Twelfth Avenue South. He named the area Crayton Cove in honor of E. W. "Ed" Crayton, who guided the development of Naples from 1913 until his death in 1938. Plans for the new Crayton Cove development included a boathouse, docks, shops, and offices. According to the *Collier County News*, highlights of the February 3, 1950, Grand Opening included, "Susie Q, age 12, and her boon companion, two-year-old Shirley, the Roger's Brothers two congenial pachyderms." Hundreds of people attended the celebration, and the newspaper noted, "Suzy [*sic*] and Shirley proved to be the heavy imbibers of the day, in both the beer and pop departments." This rare postcard view of the north finger of the City Dock was mailed in 1955. The still-submerged site of the Cove Inn is just beyond the dock. The city's water tower is visible in the background. (Courtesy of Nina Heald Webber.)

By 1952, Crayton Cove was the headquarters of the Naples Guide Boat Association, which included more than 14 charter-boat captains, including Capt. D. R. House Jr. of the *Dana* and Capt. Jack Cannon of the *Victory Morn*. Charter fares ranged from $25 to $45 per day for a party of four, with additional fees for Shark River trips. Above, visible in the background of this west-facing view, is a sign for the Pub, part of Benny Morris's White Pelican restaurant. Below is an southeast-facing view of the city dock, *c.* 1964, with the pilings of the new Cove Inn visible in the foreground. Royal Harbor is across the bay.

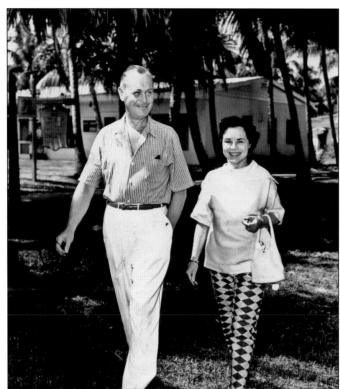

This photograph of Robert Montgomery and his wife, Elizabeth, ran on the front page of the March 25, 1955, edition of the *Collier County News*. According to the caption, the noted actor was planning to "test his fishing luck aboard Julius Fleischmann's *Camargo III*." The celebrity couple was photographed as they walked from the Naples Hotel to the Seminole Market on Third Street South. Peg Bradley's Zita shop, one of the first designer fashion stores in Naples, is visible in the background.

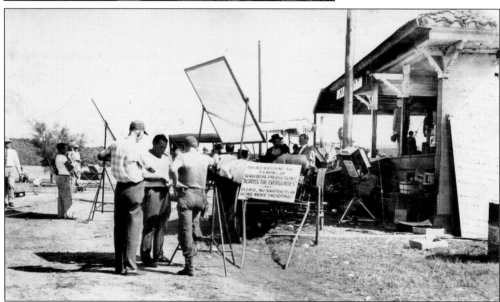

More actors came to Naples in 1958 for the filming of Budd Schulberg's production, *Wind Across the Everglades*. Stars included Burl Ives, Gypsy Rose Lee, and Christopher Plummer in a drama about bird poaching or "plume hunting" in southwest Florida during the late 19th century. A sign on the set announced, "You are watching the filming of Schulberg Productions 'Across the Everglades,' but please, no snapshots or home movie shooting!"

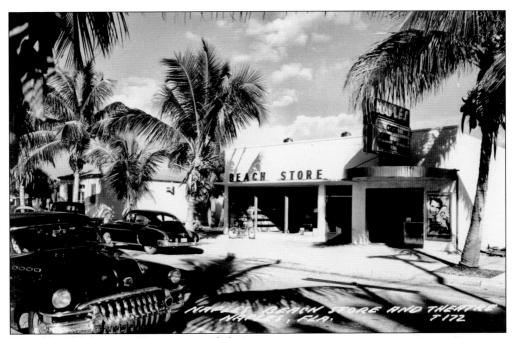

Arnold and Margaret Haynes moved their popular Beach Store from the old Naples Company Building on Third Street South to its new location across the street in 1948. According to the *Collier County News*, "The new building, one of the largest store buildings in Naples, was constructed by Haynes." Right next to the Beach Store building, Arnold Haynes also erected a Quonset hut to house the couple's newest venture, the Naples Theatre. In the above image, a poster for Cary Grant's 1950 film, *Crisis*, is visible n the right. By 1952, the theater was air-conditioned—just in time for the premier of *Distant Drums*, which was filmed in Naples and starred Gary Cooper and a host of local bit-part actors. Right, a *c.* 1962 theater ticket lists the 1959 hit, *Ben Hur*, the 1962 film *Light in the Piazza*, and *Everything's Ducky*, which debuted in 1961. (Above courtesy of Nina Heald Webber; Right courtesy of Gerry Johnson.)

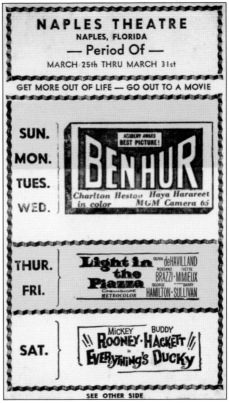

Although Naples became a city in 1949, the nearest hospital was 40 miles away, in Fort Myers. Fund-raising began in 1950 for a small emergency clinic, but by 1953, supporters envisioned a 30-bed hospital. A new, city-wide fund-raising campaign began on April 24, 1953, at the Naples Beach Hotel, with more than 300 people attending what the *Collier County News* called "one of the most spirited gatherings ever held in Naples." Less than a month later, 716 families had pledged more than $381,000 for the new Naples Memorial Hospital.

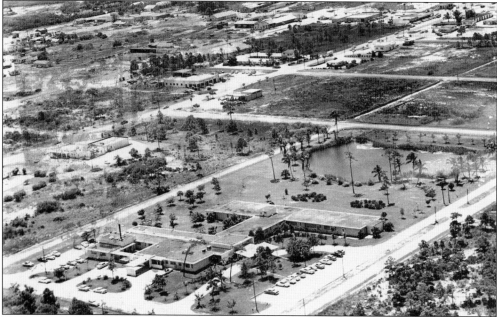

By 1955, plans called for a 52-bed facility, and the name was changed to Naples Community Hospital. The new hospital was dedicated on Sunday, March 4, 1956, with more than 2,000 people attending the opening ceremonies and touring the facility. According to Police Chief Cale Jones, "If the area could have held more cars within a reasonable distance, the total attendance would have topped everything, including Swamp Buggy gatherings." In this southeastern-facing view, Four Corners is almost visible in the upper right side of the photograph.

The new hospital was state of the art—and stylish—with a lobby that "will make you let out a low, soft whistle," wrote *Collier County News* writer Thomas Hayer after a pre-opening tour of the facility. In his editorial, he stressed that "every bit of added luxury was paid for by an individual from Naples" and not from building fund contributions. "Mr. and Mrs. Lester Norris of Keewaydin paid for the services of Dorothy Draper, the nationally-known interior designer. They also paid for the costly furnishings she recommended. In the lobby, practically everything is individually designed for this particular hospital." The hospital kitchen was also furnished with state-of-the-art equipment, including a "do-it-all" Hotpoint stove, complete with a grill and two built-in deep fat fryers. Food was delivered to patients in special "heated mobile wagons."

The new Naples Community Hospital also featured a Hospitality Room, operated by the members of the hospital auxiliary. The room featured a complete snack bar and gift shop. Nearby the Day Room was furnished with a brand-new large-screen television set, donated by Russ Stahlman. According to hospital administrator Denis J. DeManche, "The TV donation means that our patients will have a completely equipped Day Room from the very outset. Not many new hospitals can say that." The hospital celebrated another milestone on March 5, 1956, just one day after its official opening, when Mrs. V. J. Miller of Naples delivered the first baby born in the hospital. The *Collier County News* reported, "Many gifts, long-planned for the hospital's first baby, will be heading the Millers' way." Gifts included $50 from the Old Cove restaurant in Crayton Cove.

Two

"Stop and Stay for Awhile"

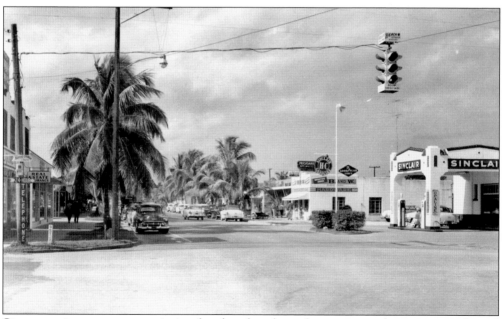

Since tourism was a top priority for the chamber of commerce, the group conducted a spot check of cars stopping at "a Four Corners filling station" in 1948. The informal survey revealed that "13 of 23 cars had no idea that they were within five blocks of the Gulf of Mexico." The chamber spearheaded the placement of promotional signs, including one above the Four Corners traffic light which announced, "Beach Straight Ahead," visible in this *c.* 1953 postcard. (Courtesy of Nina Heald Webber.)

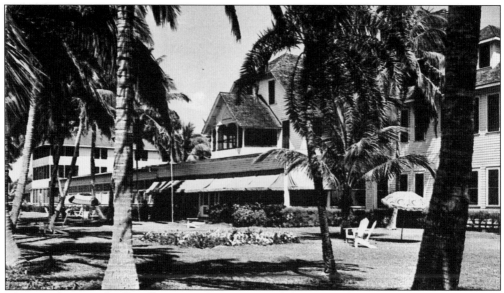

The Naples Hotel officially opened in 1889 and for more than 30 years was the only hotel in the town. In 1946, the hotel and other holdings of the Naples Improvement Company were sold to Henry B. Watkins, W. D. McCabe, and several other partners, who formed the Naples Company. Renovation and redecoration of the hotel began immediately, and by 1949, the 135-room hotel, also called the Naples Beach Hotel, was operating year-round. (Courtesy of Nina Heald Webber.)

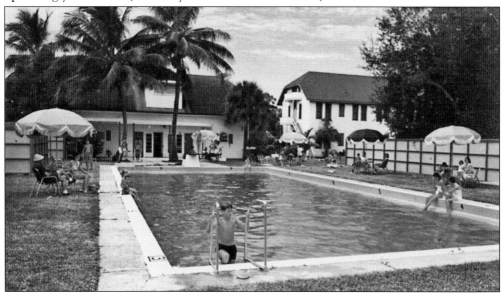

Fourth of July celebrations during the summer of 1949 broke all city records for tourism, and an editorial in the *Collier County News* stated, "We have broken the ice as a summer tourist resort." The report continued, "The Naples Hotel, open for the summer for the first time in its history, was host to 135 guests each night, and the swimming pool did a splashing business." The caption on the back of this postcard, mailed in 1959, states, "The spring fed swimming pool on the terrace of the Seminole Room is a favorite spot for guests of the Naples Hotel." (Courtesy of Nina Heald Webber.)

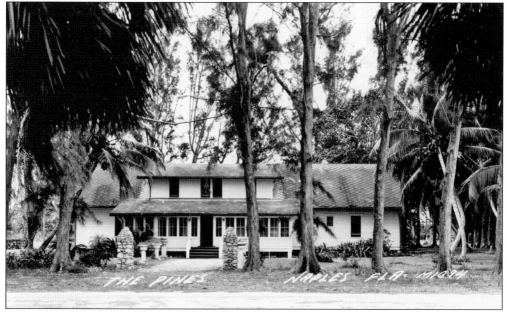

George M. Hendrie's estate, the Pines, was located on Twelfth Avenue South between the Pier and the Naples Hotel. The estate covered a city block and was once considered "the showplace of Naples." In 1946, the property was converted into a 20-room annex to the Naples Hotel. (Courtesy of Nina Heald Webber.)

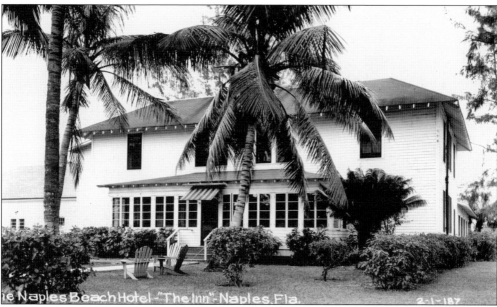

In 1946, the new owners of the Naples Hotel announced, "The building generally known as the Naples Inn, along with the new annex, The Pines, will be open year-round, due to the increasing popularity of Naples and all of Florida as a summer resort." Summer tourism grew slowly, however, and a May 1948 *Collier County News* advertisement entreated, "Give the little woman a summertime treat! The Naples Inn now serving three fine meals every day." (Courtesy of Nina Heald Webber.)

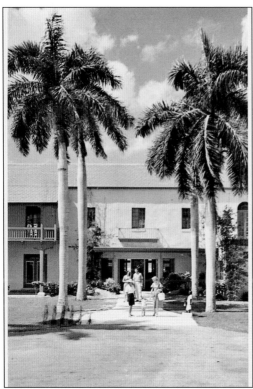

Allen Joslin's Beach Club opened in 1931 to serve as the clubhouse for the town's first 18-hole golf course. Eventually the clubhouse and golf course were acquired by the partners of the new Naples Company. By 1949, kitchenette apartments and hotel rooms were available for Naples Hotel guests who wanted to play golf. (Courtesy of Nina Heald Webber.)

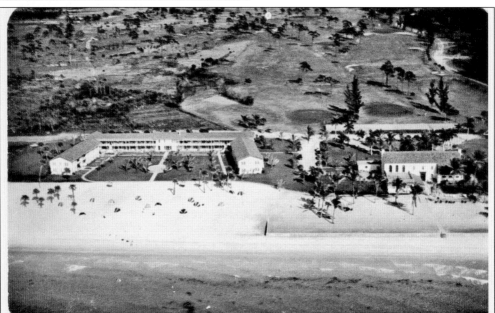

The caption on the back of this postcard, mailed in 1950, states: "The Naples Beach Club and Apartments—Three new perfectly appointed club buildings containing apartments and hotel rooms, and a magnificent club house of gracious Spanish architecture—grouped in a luxurious garden of more than four acres directly on the Gulf of Mexico." The original Joslin clubhouse is visible on the right. (Courtesy of Nina Heald Webber.)

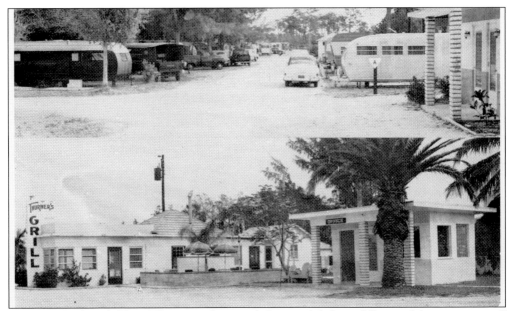

In 1948, Carl and Clara Thurner advertised the availability of "beautiful new cottages" at their trailer park, located "2 1/2 miles north of the traffic light" on the Tamiami Trail. By 1957, the park offered 12 cottages, 7 efficiency apartments, with "air-conditioning and Panel Ray heat," and 100 spaces with patios for trailers. A sign for Thurner's Grill is visible on the left. (Courtesy of Nina Heald Webber.)

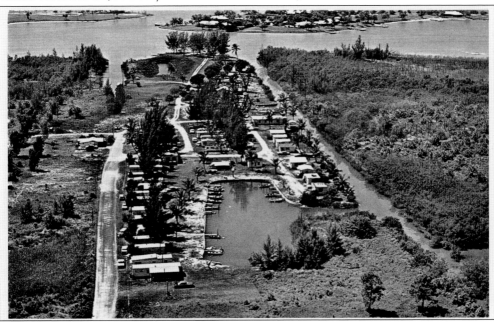

Jackson's Fish Camp kicked off the 1952 chamber of commerce's second annual "Visitor Appreciation Days" with a "big campfire and wiener roast." The camp, located one mile from the Gulf by water on Naples Bay, offered cottages, house trailers, and trailer spaces. The name was changed to Jackson's Gateway Harbor in 1956. Port Royal is visible in the background of this c. 1960 postcard. (Courtesy of Nina Heald Webber.)

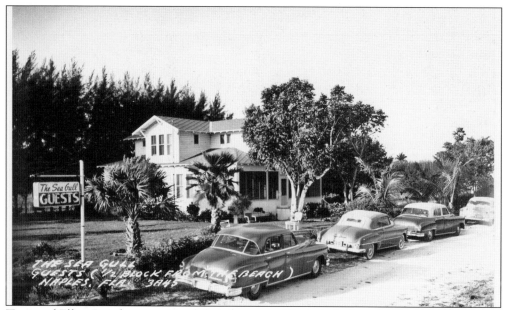

Tom and Ellen Brooker converted their home on Twentieth Avenue South and Gordon Drive into the Sea Gull Guest House in the late 1940s. In 1949, the city council informed Tom Brooker he could "put up a sign with the word 'Sea Gull' on it directly on Gordon Drive to advertise his rooming house, but if he makes it 'Sea Gull—Guests,' he would have to set the sign back 25 feet from Gordon Drive." (Courtesy of Nina Heald Webber.)

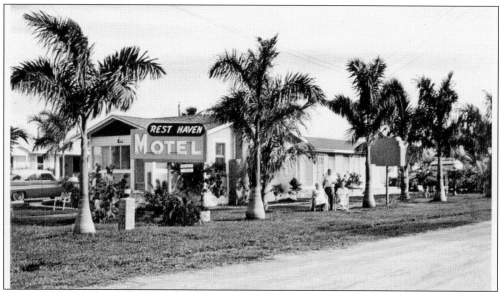

Nicolo "Nick" Porriello bought a quarter-acre lot on the corner of Eighth Avenue South and Tenth Street South in 1946. A year later, he built a four-room house, and as demand for tourist accommodations increased, he enlarged the building and began renting rooms. In 1953, he named it the Rest Haven Motel. The caption on the back of this c. 1956 postcard states, "100% on State inspection. Quiet neighborhood, near depot and Route 41." (Courtesy of Nina Heald Webber.)

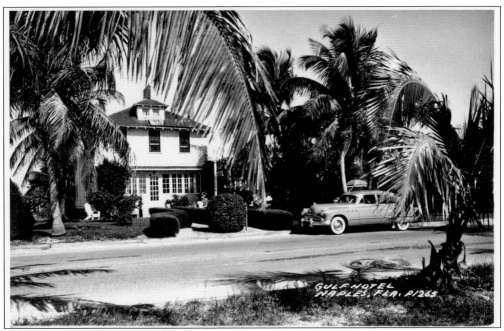

In 1935, Dan and "Willie" House moved their three-bedroom home from Fifth Avenue North to Fifth Avenue South, added six bedrooms and four bathrooms, and opened the Gulf Hotel. When Max and Frances Day bought the property in 1948, the hotel had 15 bedrooms and 13 bathrooms. According to the message written on the back of the above postcard, mailed in the 1950s, "This little hotel is a comfortable homey place, with good home cooking. People are friendly and accommodating and (most importantly) any number of fishing spots are close by." (Courtesy of Nina Heald Webber.)

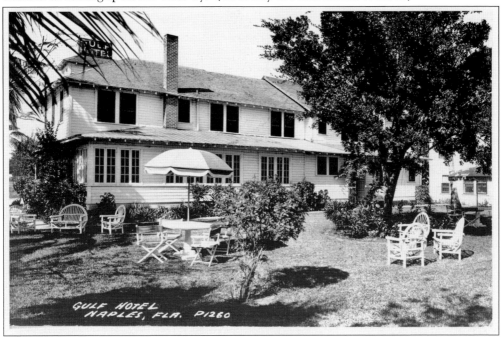

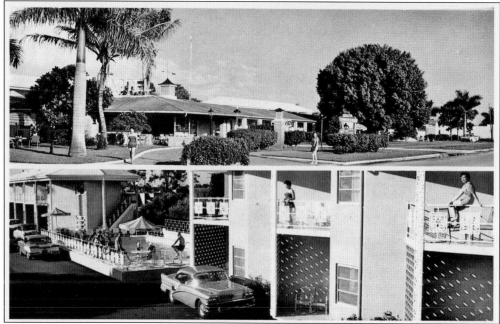

By August 1949, three new motels were being built along the Tamiami Trail in Naples, including the Trail's End Motor Hotel, the Sea Shell Motel, and the Motel Naples. According to a *Collier County News* report, "The three motels will have combined units totaling approximately 70, and costs of all three will run upwards of $160,000." The Trail's End Motor Hotel, pictured above, offered 50 rooms and, according to the caption on the back of this postcard, "the most beautiful swimming pool in Naples." The brand-new, 10-room Sea Shell Motel, owned by Mr. and Mrs. Carl Pracil, opened on October 21, 1949. (Courtesy of Nina Heald Webber.)

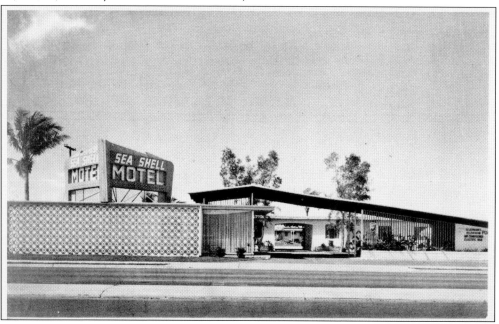

A full-page advertisement in the *Collier County News* announced the new Motel Stewart on the Tamiami Trail, north of Four Corners, would be "open for inspection" on Thanksgiving Day 1952. Owners Troy and Florence Stewart offered refreshments and tours of their new 20-unit motel, which featured air-conditioning, broken tile flooring, and "tastefully and comfortably furnished rooms," including several with one or two bedrooms and a living room, "ideal for a couple with servant or nurse in attendance." The Stewarts held a naming contest for their new motel and received more than 670 entries from 43 states. Mrs. Vernon H. Thompson of Naples was declared the winner with her suggestion of Motel Stewart. The caption on the back of this c. 1952 postcard states, "Motel Stewart, exclusive but not expensive. Close to golf course, beach, fine fishing, hunting and shelling. Get together TV lounge and coffee bar." (Courtesy of Nina Heald Webber.)

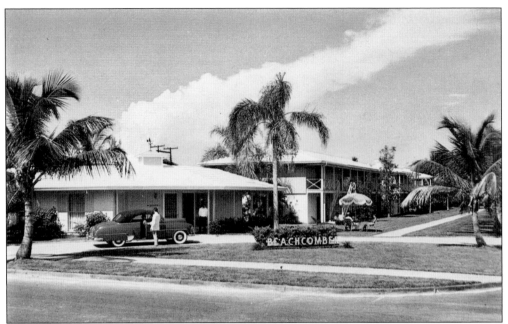

Construction of the Beachcomber started in June 1952, and the project was hailed in the *Collier County News* as "one of the largest single building projects in the history of Naples." Bids ran from $232,000 to $341,000 for the 60-unit building on the western end of Fifth Avenue South. The Beachcomber opened in January 1953, and the brand-new motel advertised: "Lazy loafing with every comfort and convenience. Sixty luxurious apartments, suites or rooms are available, with individually controlled air-conditioning and heating. Offering handy kitchenettes, sound-proofed walls, private porches, maid service, a la carte breakfasts, box lunches, canapés for cocktails, everything!" (Courtesy of Nina Heald Webber.)

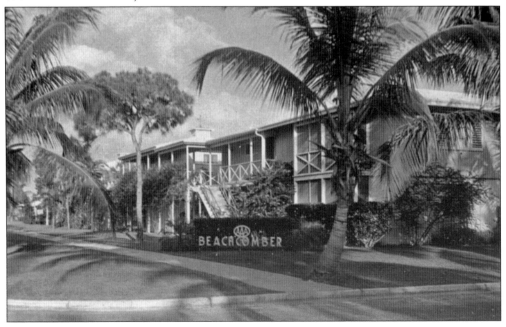

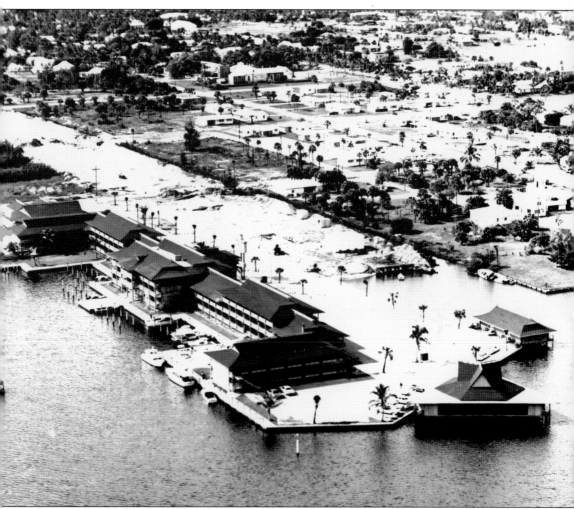

"It's a 'Go' for the New Old Cove," was the front-page headline of the May 26, 1963, edition of the *Collier County News*. Full-scale construction of the million-dollar motel and marina was slated to begin in four weeks, after compaction tests certified the fill dredged from the bay the year before was firm enough to begin construction of the 116-unit motel. The Tahitian-style structure was designed by William Zimmerman, one of the architects who designed the Tahitian-style, post–Hurricane Donna pier. The motel and "yachtel" opened in 1964, but five years later, the failing venture was bought by Kenney Schryver and a small group of investors. The group converted the hotel into a "condominium hotel," selling the rooms as condominiums and offering the option of managing the units as hotel rooms for the owners. Although the concept was new, 52 of the 102 units sold in two weeks, and the Cove Inn became the one of the first successful condominium hotels in Florida.

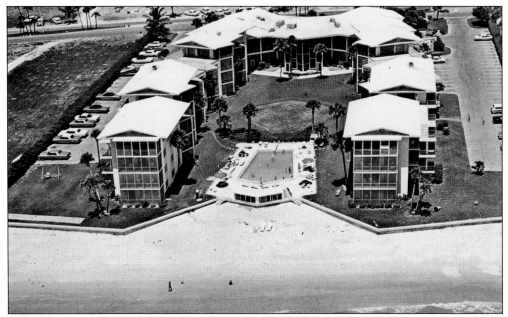

Ground was broken on June 30, 1963, for E. H. Marhoefer Jr.'s newest project, the Edgewater Beach Apartments, a million-dollar beachfront building designed by architect Nelson A. Faerber. The three-story structure opened in January 1964, offering 124 units, including hotel rooms, efficiencies, one-bedroom apartments, and two-bedroom penthouse suites. During construction of the Edgewater, Marhoefer's construction company was also building the Park Place cooperative across the street and the Cove Inn in Crayton Cove. (Courtesy of Nina Heald Webber.)

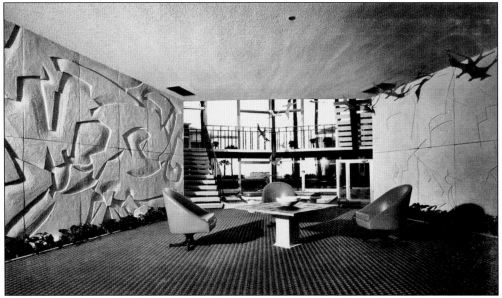

Sculptor Albert Vrana designed the lobby of the Edgewater Beach hotel. According to the caption of this c. 1964 postcard, "An imaginative person can discover beachcombers and sun-worshipers interwoven in the walls as bronze man-of-war birds wing their way to the nearby waters of the Gulf." (Courtesy of Nina Heald Webber.)

Three

GOOD FOOD, GOOD TIMES

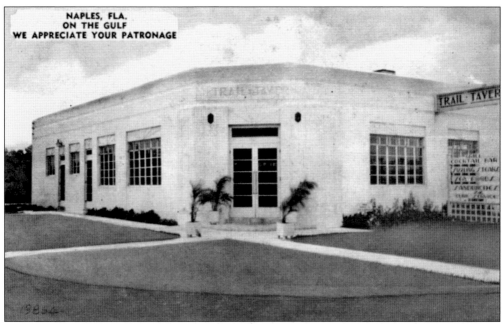

NAPLES, FLA.
ON THE GULF
WE APPRECIATE YOUR PATRONAGE

Located on the corner of Third Avenue South and the Tamiami Trail, just three blocks from Four Corners, Pat Aldacosta Combs's Trail Tavern opened in 1939. By 1941, when this postcard was mailed, it offered a "grill, cocktail bar, sizzling steaks, seafoods, sandwiches and curb service." The tavern was sold in 1953, and according to the *Collier County News*, "A $25 war bond was won by Mrs. Sherrel Slater for suggesting the name, 'The Anchor Restaurant and Cocktail Lounge' for the former Trail Tavern." (Courtesy of Nina Heald Webber.)

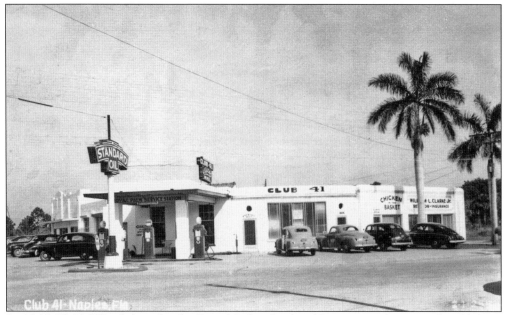

In 1946, Eli E. Winch bought the Royal Palm Cocktail Lounge and renamed it Club 41 in recognition of its prime location on the northeast corner of Four Corners on U.S. 41. Two years later, he sold the club to John Waltman, who immediately announced plans to install air-conditioning. In honor of the town becoming a city in 1949, a full-page advertisement in the *Collier County News* announced, "Club 41, the only air-conditioned bar and restaurant in the city and county salutes the people of Naples. Try our new cocktail special, 'The City of Naples.'" Below, a full-page advertisement in the April 8, 1949, edition of the *Collier County News* featured a photograph of Club 41's Bamboo Bar, "the most popular oasis in Collier County."

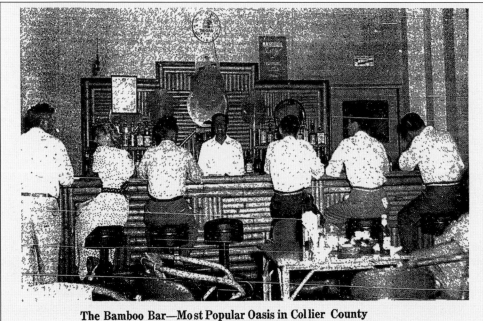

The Bamboo Bar—Most Popular Oasis in Collier County

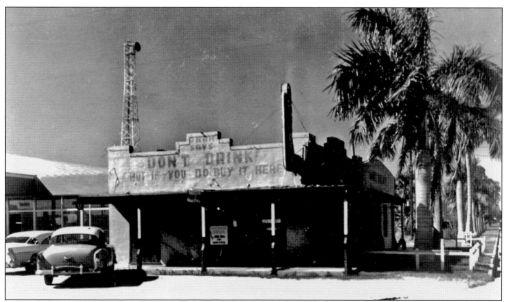

Omah Clarke's eye-catching liquor store sign, "Don't Drink! But if you do, buy it here," became a well-known landmark on the Tamiami Trail during the 1940s and 1950s. The self-styled "Old Hound Dog" sold his business in 1957, and an editorial in the *Collier County News* noted: "With its disposal will end another survivor of Naples' pioneer roughing days. Clarke originally operated a filling station and restaurant at that location in the days when he had practically the city's only eating place other than the Naples Hotel. Clarke remembers selling a quarter of a two-pound roaster, mashed potatoes and two slices of toast for .25 cents in those 'pre-repeal' days." The site was later occupied by the Swamp Buggy Lounge.

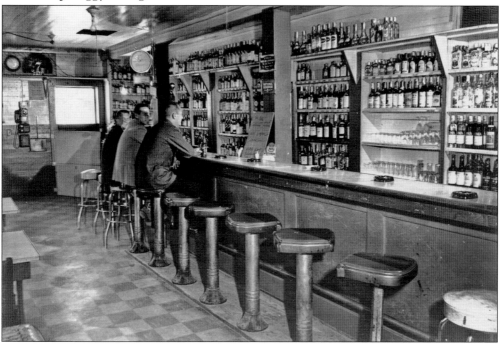

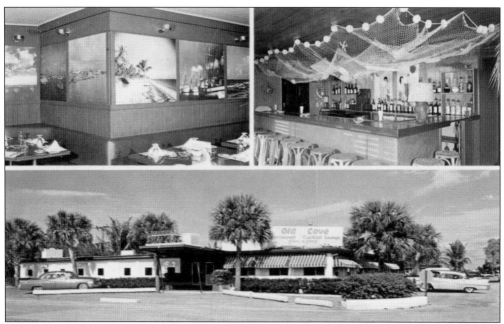

In August 1956, B. W. "Benny" Morris sold his Old Cove restaurant in Crayton Cove to Dr. William Yeaman of Detroit. The landmark restaurant, formerly called the White Pelican, was well known for its snapper chowder and would later be hailed in the December 1956 issue of *Holiday* magazine "as perhaps the most interesting restaurant in town." Yeaman also owned and operated a large restaurant in Detroit. In July 1956, the Old Cove Luncheon Special included a hot roast beef sandwich for $1.15 or a baked ham and cheese sandwich for 70¢. Both lunch specials included a free glass of Michelob beer. (Courtesy of Nina Heald Webber.)

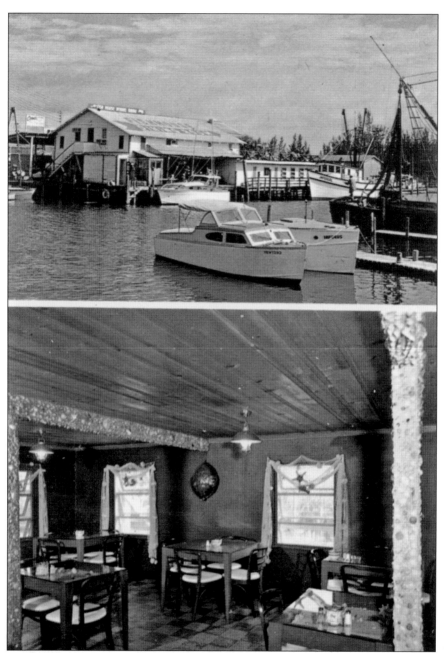

In 1953, Pat Combs sold the Trail Tavern and, with her husband, Bob, opened the Fish House Dining Room, located on the eastern side of the Gordon River Bridge, right next to their Combs Fish Company building. Special case-like tables, visible in the lower image, were designed to showcase Pat Combs's shell collection. Fresh fish came directly from the fishing fleet that docked behind the restaurant. According to a special feature story in the December 1956 issue of *Holiday* magazine, the Fish House was so popular that "reservations two weeks in advance in season are not unusual." The Fish House was sold in 1971, and the name was changed to Kelly's Fish House. (Courtesy of Nina Heald Webber.)

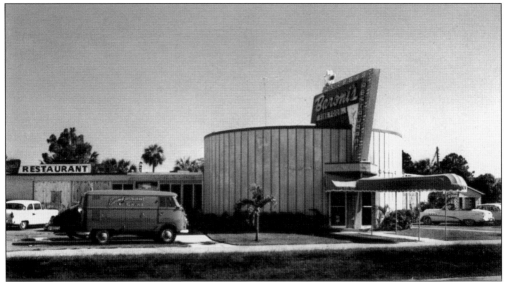

Bob and Helen Baroni came to Naples in 1951 and worked at Club 41 until 1955, when the couple purchased the diner across the street. A year later, the small building was razed and the couple built a new, 260-seat restaurant, Baroni's, which opened on January 18, 1957. A 1958 phone book advertisement proudly claimed the restaurant, designed by architect Nelson Faerber, had "the only circular bar on the west coast." The couple sold their popular restaurant to Robert Fettig in 1963. (Courtesy of Nina Heald Webber.)

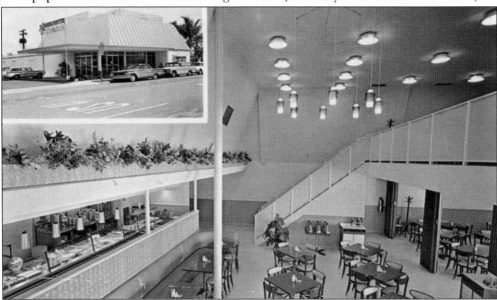

In August 1963, Julius "Junkie" Fleischmann, a wealthy philanthropist and entrepreneur, announced plans to build a cafeteria on the northeast corner of Four Corners. William Zimmerman, architect of the Tahitian-style Cove Inn, designed the new, 220-seat Lamplighter Cafeteria, the first cafeteria in Naples. On November 22, 1963, the *Collier County News* reported, "A most colorful addition to Fifth Avenue South is the new Lamplighter Cafeteria, resplendent in turquoise blue, where workmen are rushing construction to be open for the coming season." (Courtesy of Nina Heald Webber.)

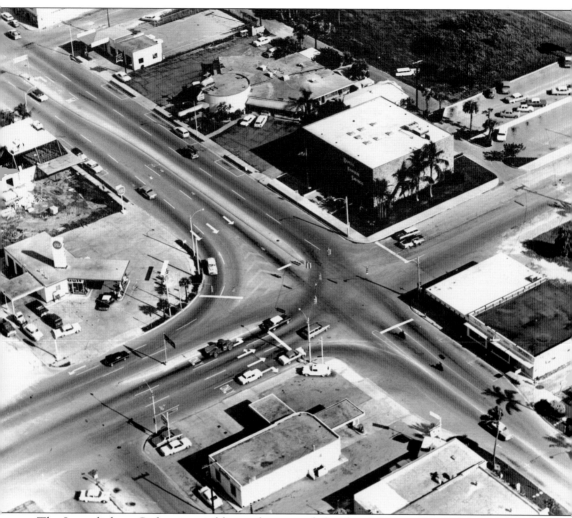

The Lamplighter Cafeteria, visible on the upper left side of this southeast-facing view of Four Corners, was under construction when this photograph ran in the *Collier County News* on November 5, 1963. The cafeteria was leased by Mrs. Agnes N. Rhodes and Archie T. Ford of Fort Myers, who invited residents and visitors to an open house on Sunday, December 8, 1963. The cafeteria officially opened for business two days later. Across the street is Baroni's and the landmark circular bar. The new Naples Federal building, visible in the upper right, opened on December 16, 1961. Reid's Sinclair Station is on the northwest corner, and Naples Liquors is on the southwest corner. The caption below the photograph noted, "Not a building stands at the intersection that was there five years ago."

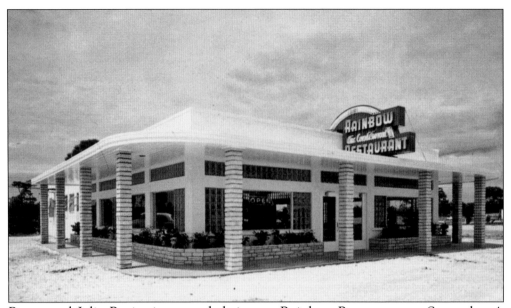

Benny and Julie Benjamin opened their new Rainbow Restaurant on September 4, 1953. The 120-seat, air-conditioned building, just three blocks from Four Corners on the north Tamiami Trail, featured colorful plaster panels on the interior ceiling, formica-topped tables, a mural of the Naples fishing pier, and, according to Julie Benjamin, a shell display "unequalled in Naples." (Courtesy of Nina Heald Webber.)

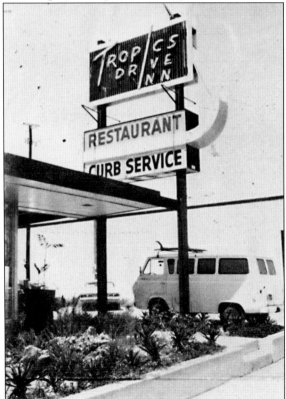

In January 1955, the brand-new Tropics Drive Inn advertised in the *Collier County News*, "Position open for fry cook. Male preferred. Experienced, neat and congenial, for year-round employment." Applications were also being taken for "car hop girls." The drive-in, six blocks north of Central Avenue, on the Tamiami Trail, became a favorite hangout for high school students. This photograph was featured in the 1970 Naples High School yearbook. (Courtesy of Nancy Evans.)

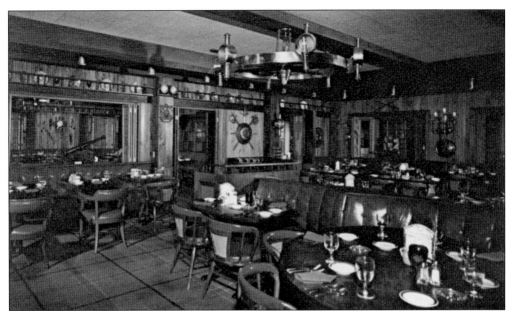

The Piccadilly Pub opened in March 1961; owner Helen Peppard advertised the Fifth Avenue South restaurant as "authentic in atmosphere and décor as possible for any pub straight out of Merrie Old England to be." A portion of Peppard's extensive antique pewter collection is visible on the wall in this c. 1962 postcard. The pub was located in one of the few two-story structures on the busy shopping street. (Courtesy of Nina Heald Webber.)

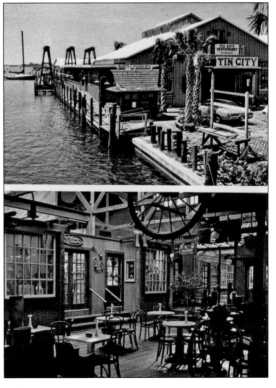

In 1976, Kenney Schryver and several partners converted the tin sheds of an old fish house on the southwestern side of the Gordon River bridge into the Old Marine Marketplace featuring a collection of shops and the Tin City Restaurant. The restaurant was sold to Ken Beattie of Fort Myers in 1977, and the name was changed to Kenny's Tin City. (Courtesy of Nina Heald Webber.)

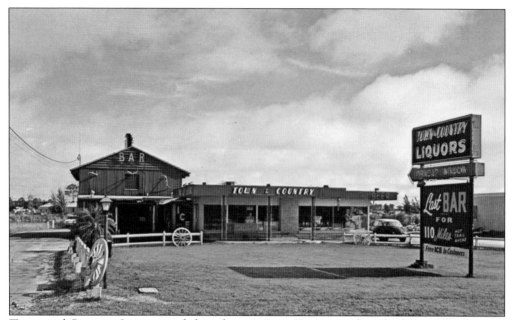

Town and Country Liquors and the adjacent Barn Bar opened in the late 1950s, located on the eastern edge of Naples, on the "south Trail." A sign, visible on the right, warns travelers: "Last bar for 110 miles. Hot Trail ahead. Free ice to customers." The liquor store and Barn Bar were razed in 1983 to create additional parking for Bob Taylor Chevrolet. (Courtesy of Nina Heald Webber.)

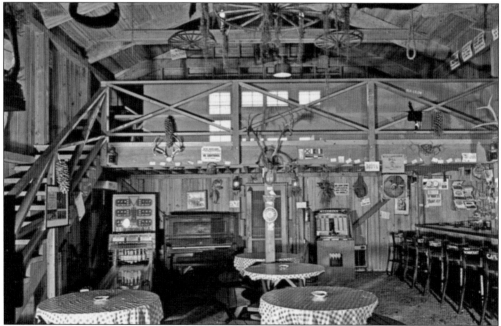

Dusty's Barn Lounge claimed to be the most unusual cocktail lounge in Florida. The caption on the back of this c. 1968 postcard reads: "Wall-to-wall (sawdust) carpeting. Don't mess up our ashtrays, throw your peanut hulls on the floor. We don't make any money, but we sure have a lot of fun. Visit our Hayloft." (Courtesy of Nina Heald Webber.)

Four

FUN-IN-THE-SUN

Collier County News columnist Tom Morgan noted superlative charter boat catches in his weekly "Along the Gulf" fishing column and on April 3, 1953, wrote, "The trouble with fishing in the Naples part of Florida is it's so good, it makes even truthful characters look like liars—and liars look truthful." (Courtesy of Nina Heald Webber.)

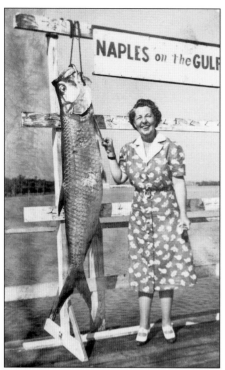

Naples was already well known as a tarpon fishing destination when the Naples Chamber of Commerce and the Naples Beach Hotel sent a tarpon to Arthur Godfrey in January 1950. The showy specimen was sent in response to Godfrey's on-air remark that "he had been to Naples to catch a tarpon, but only caught a cold." Godfrey took the joke in stride and showed the tarpon on CBS. On the back of this Back Bay/City Dock postcard, mailed in 1941, "Bess" wrote, "Now you all gaze on this for a fish." (Courtesy of Nina Heald Webber.)

The 1973 "Visitors Edition" of the *Collier County News* included this photograph of an unidentified fisherman (left) and SportSpot employee "Ed" on the SportSpot Marina dock, just south of the City Dock. The SportSpot in Crayton Cove officially opened on January 28, 1950, and just a few months later, plans were unveiled for the construction of a 132-foot boathouse for a rental fleet of 18 sport fishing boats.

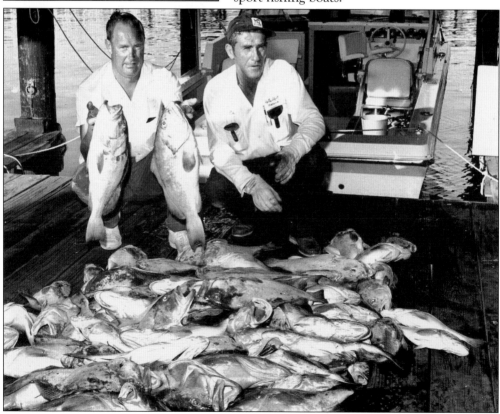

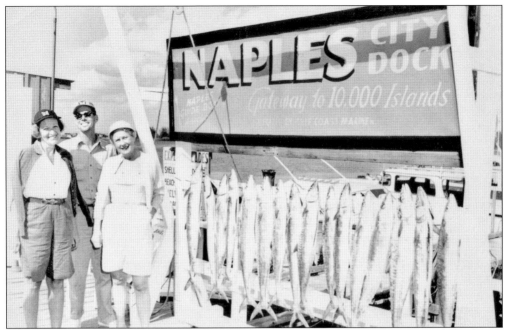

According to a February 25, 1949, *Collier County News* editorial, "Most of the boats are out every day, and the very photogenic new sign on the end of the dock is a perfect background for pictures of fish caught." In this *c.* 1950 photograph, fishing guide Rob Storter, who owned the *Nanna*, poses with two unidentified visitors and an impressive kingfish catch. (Courtesy of the Collier County Museum, Naples, Florida; Lucy House Storter Collection.)

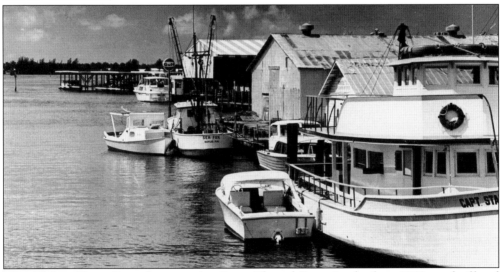

The 65-foot *Capt. Starn* became the *Capt. Elwood Starn* in the late 1960s and offered deep-sea fishing in the gulf. According to the caption of a *c.* 1970 promotional postcard, the charter boat offered "Fish finder, twin G. M. diesels, snack bar, rod and reel rental. Free parking at boat. Daily 8:30 a.m. to 4:30 p.m. at Gordon River Bridge on U.S. 41 E." The fish house behind the *Capt. Starn* became part of the Old Marine Marketplace in 1976.

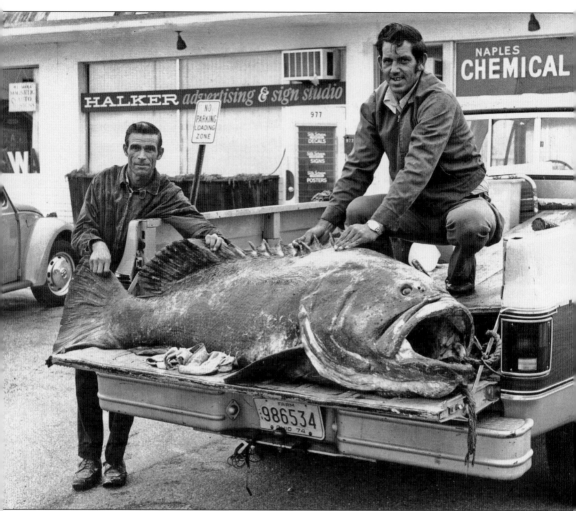

"A Whale of a Catch" headlined this sports section photograph in the November 12, 1974, edition of the *Naples Daily News*. Charles Patterson (right) with help from his brother-in-law, Bud Gammell (left), caught this 402-pound goliath grouper just south of Naples, and according to the caption, "It took Patterson, Gammell, the wife and all the kids to load it into the truck. The giant sea bass was seven feet, two-and-a-half inches long and was weighed in at Kelly's Fish House." Patterson caught a 398-pound goliath grouper the year before. The super-sized species, also known as jewfish, were occasionally caught off the Naples Pier, and Eddie Watson, pier manager during the late 1940s, reminisced during a 1961 interview with the *Collier County News*, "To my knowledge, the largest fish caught off the pier was a jewfish weighing a little over 600 pounds. We had to get a truck with a crane to pull it up onto the pier."

"Joe Garagiola . . . match this snook!" was the caption of this March 3, 1973, photograph in the sports section of the *Naples Daily News.* The baseball star and celebrity broadcaster's nearly seven-pound snook became the benchmark size to beat to win a prize in the upcoming Jack Nicklaus Sport Fishery Research Foundation benefit tournament.

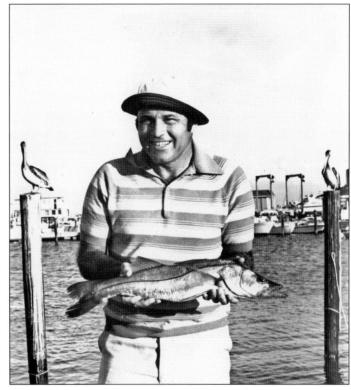

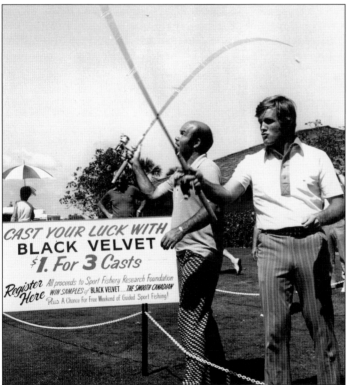

Sports personality Joe Garagiola (left) and American Football League All-Star Bob Griese (right) tried a game of "skish," a combination of "skeet" and "fish," at the Marco Island Country Club during the 1973 Jack Nicklaus Sport Fishery Research Foundation benefit tournament. For $1, would-be anglers got three chances to cast a plug into a ring.

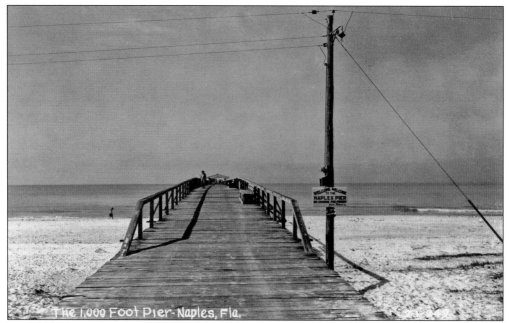

By 1945, the pier was owned and operated by the town of Naples, and a sign at the entrance announced "No charge for fishing." The pier was considered a prime fishing spot, and in June 1952, the *Collier County News* reported that Al Pondrom, a winter visitor and "a steady client at the Pier," caught from September to June: 860 mackerel; 40 trout; 60 blue runners; 16 bluefish; 11 reds totaling 149 pounds; 100 jacks; 7 cobia; 2 snook, 8 and 12 pounds; a 20-pound tarpon, 7 flounders, 60 ladyfish, 2 mangrove snappers, 9 small sharks, and 100 or more "trash or bottom fish." Note the car on the pier in the postcard below. (Courtesy of Nina Heald Webber.)

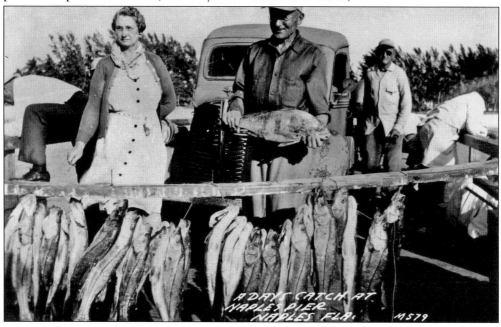

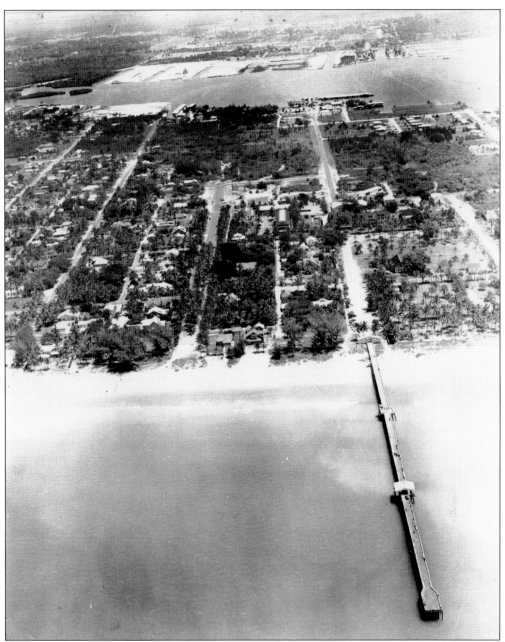

The Naples Pier, pictured before Hurricane Donna came ashore on September 10, 1960, was first built in 1888, then rebuilt after the hurricanes of 1910, 1926, 1944, and 1960. The pier served as a vital gateway to the remote winter-season resort for nearly 30 years but lost its importance as a boat dock after the arrival of train service in 1927 and the opening of the Tamiami Trail in 1928. This c. 1958 aerial shows the careful placement of the Naples Hotel, visible in the right center, conveniently situated between the pier and the bay. The hotel opened in January 1889 and was the first hotel in the town. The main building was torn down in 1964, and the northern wing was demolished in 1978.

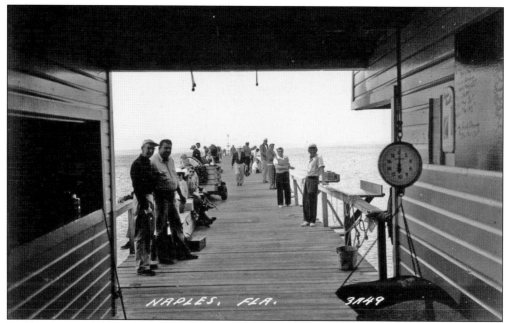

By 1948, a snack bar and tackle shop had been built onto the pier, and an advertisement in the *Collier County News* proclaimed: "Everybody's always welcome at the Naples Pier. Never any charge for fishing. Rods, reels, tackle for rent and sale. Live shrimp, minnows, sand fleas and cut bait for sale. Refreshments while you fish. We buy your catch." On November 17, 1950, Ted Yates Jr. reported in his *Collier County News* "Along the Gulf" fishing column: "Things have been happening fast and furious-like at the Naples Pier. Excitement ran so high that one gentleman rushed to the counter of the tackle shop at the pier and ordered 'A coke and a small mullet, please.' " (Above courtesy of Nina Heald Webber; Below courtesy of the Florida State Archives.)

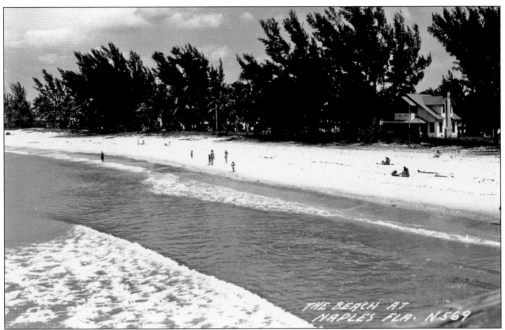

Mild winter weather and miles of pristine, publicly owned beach continued to be the primary attractions of Naples. By the late 1940s, full-page advertisements in the *Collier County News* proclaimed, "Naples greets the winter visitors, old friends and new, and wishes them happy vacationing in the sun." In February 1952, a *News* editorial by Michael Chance explained: "Here's why Naples calls them visitors instead of tourists. The dictionary says 'tour' means 'to travel from place to place,' and 'visit'—the act of going to see a person, place, etc. in a way of friendship." (Courtesy of Nina Heald Webber.)

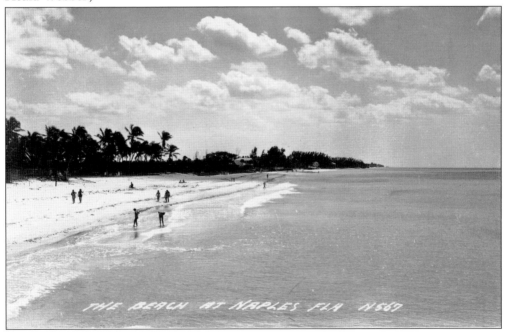

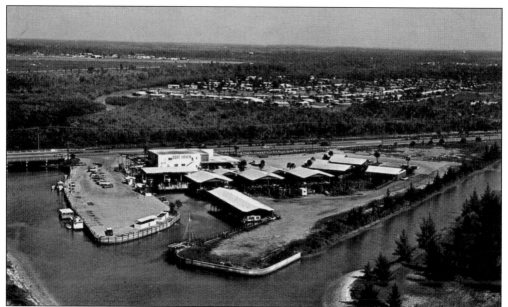

"The new star of the Naples waterfront, Boat Haven, will hold an Open House on Saturday and Sunday," headlined the October 29, 1959, edition of the *Collier County News*. Mayor Roy Smith cut the ribbon to officially open Phil Morse's million-dollar, 14-acre marina on Naples Bay. Guests were encouraged to "drop by before or after the Swamp Buggy Races, since you'll be driving right by to get to the track." (Courtesy of Nina Heald Webber.)

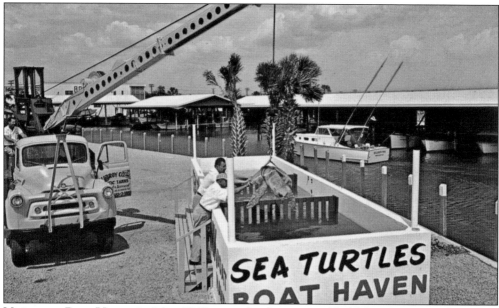

Visitors to Boat Haven in May 1962 were the first to see Phil Morse's new 30-by-8-foot turtle tank, stocked with six turtles, including a 450-pound loggerhead caught by his 14-year-old son, Cottie, and 13-year-old Steve Bomer. It took three hours for the boys to land the large sea turtle. The tank also held four small green turtles and a 40-pound loggerhead. (Courtesy of Nina Heald Webber.)

This photograph of Benjamin "Benny" Morris's boat, the *Mangrove King*, ran in the society pages of the January 4, 1952, edition of the *Collier County News*. According to the caption: "It really isn't a steamboat, but the view is somewhat reminiscent when the Mangrove King hove into view carrying members of the Beau and Belle Club from an all-day outing on Naples Bay. Nearly 30 souls, including a few grown-ups, were on the cruise with Benny Morris, master of the good ship."

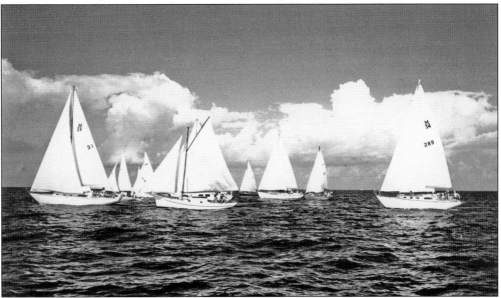

"Regatta to highlight Labor Day weekend," was the front-page headline of the August 31, 1969, edition of the *Collier County News*. The caption under this photograph noted, "some of the larger craft will be Marconi and gaff-rigged." Thirteen "offshore cruising boats" participated in the fourth annual Summerset Regatta from Naples to Marco Island, sponsored by the Naples Sailing Club and the Marco Island Yacht Club. Tim Fisher Jr., aboard *Jet 1*, took first place, and Jim Doane, sailing *Flame*, came in second.

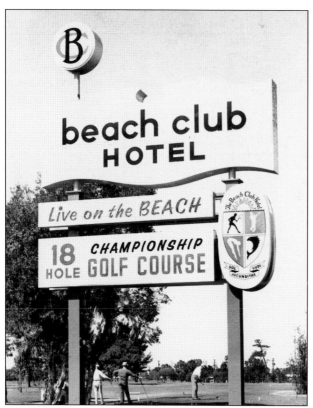

By 1966, there were five golf courses in Naples, including: the Beach Club, the Big Cypress Golf and Country Club, the Moorings Country Club, the Golden Gate Country Club, and the Hole-in-the-Wall Club. The Beach Club course opened in 1931 and was the first 18-hole golf course in Naples. In the March 28, 1952, edition of the *Collier County News*, Beach Club golf pro Paul Bell reported, "The second hole-in-one ever made on the Naples golf course, and the first ever made by a woman, was made this week by Mrs. Fred Uihlein of Milwaukee and Naples." Below, the caption on the back of this *c.* 1966 Beach Club Hotel postcard reads, "A picturesque view of the water wheel on the 18-hole Championship golf course." (Below courtesy of Nina Heald Webber.)

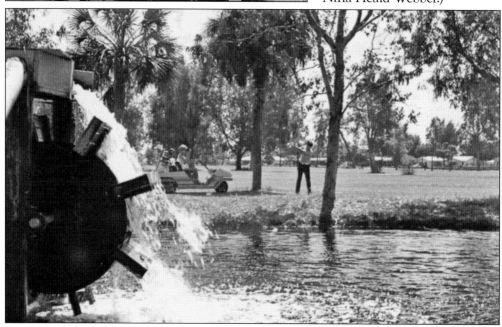

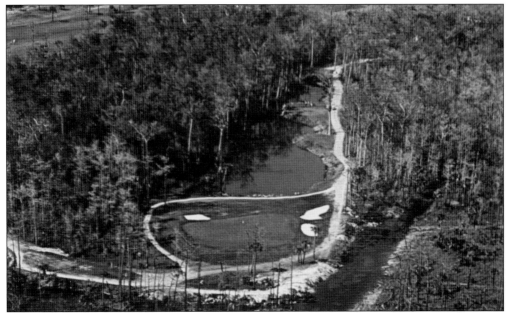

This c. 1964 postcard features an aerial view of the 11th hole of the Big Cypress Golf and Country Club. According to the caption on the back, "This hole is one of the most beautiful and demanding par 3's in the south. It offers every type of flora and fauna to be found in south Florida, and measures 225 yards in length." In 1966, winter-season greens fees for the Bill Diddel–designed course were $5. Electric carts cost $7. (Courtesy of Nina Heald Webber.)

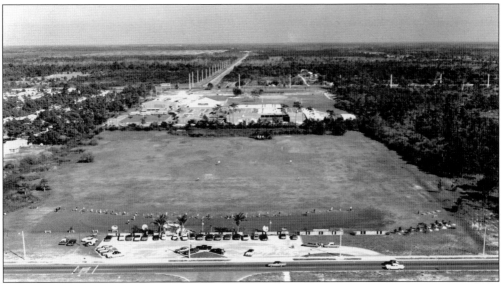

Zigfield "Ziggy" Troy, a professional golfer in the 1930s and 1940s, opened his Blue Caribbean Golf Driving Range on January 10, 1953. In this east-facing, early-1970s photograph, taken before the construction of Coastland Center began in 1977, the Tamiami Trail and the Publix parking lot are visible in the foreground. Naples High School is to the east of the range. The large east/west road visible in the background is Golden Gate Parkway.

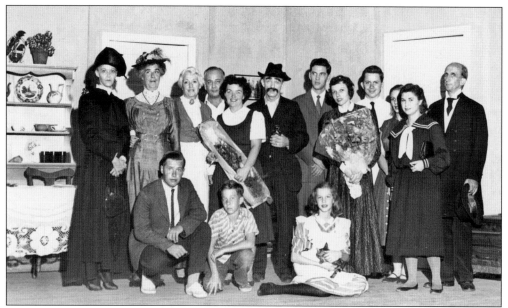

The newly formed Naples Players presented their first production, *I Remember Mama*, on March 20, 1953. According to a *Miami Herald* review, "Another cultural step in the progress of the city was taken when the newly-organized Naples Players gave their first performance at the Naples High School auditorium—a performance worthy of accomplished professionals." The cast of *I Remember Mama* included, from left to right, (first row) Tom Chirgwin, Dick Bingham, and Molly Reed; (second row) Barbara Storter, Annie Belle Miller, Florence Nystrom, Richard Bunting, Irene Jones, Lovell Meadors, Barry Storter, Verda Keen, Tom Porter, Tonie Porter, Ann Waln, and Tom Pace. In the mid-1970s, the organization rented a space in the Village Plaza on Davis Boulevard, which included an office/reception area, a single dressing room, and a 60-seat theater. (Above courtesy of the Naples Players.)

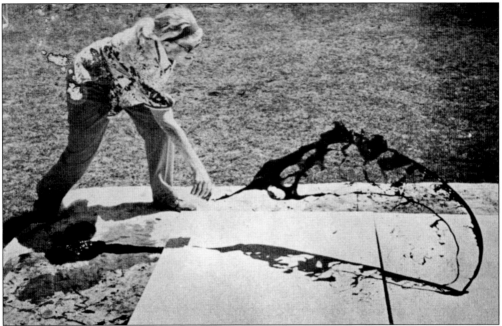

Three Naples artists, Grace Lake, George Rogers, and Elsie Upham, founded the Naples Art Association in 1954. Upham, pictured above, was a classically trained artist who began experimenting with "throw" or "pour" paintings in the mid-1960s. She frequently held art shows in her specially designed atelier/studio on Aqua Court. Below, Upham (right), in her studio with an unidentified man, signed her throw paintings on the back, so buyers could "hang them any way they want to." The Naples Art Association held its first outdoor show on the tennis courts of Cambier Park in January 1957. (Below courtesy of the Naples Art Association.)

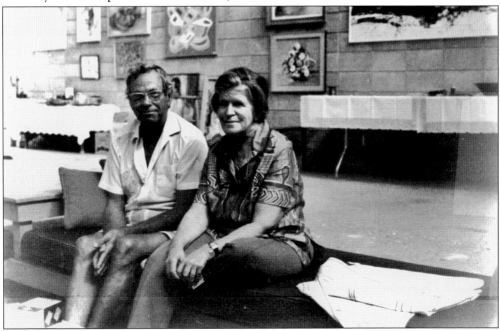

On December 6, 1947, Pres. Harry S. Truman flew into the Naples airport and was driven to Everglades City, where he formally dedicated Everglades National Park, stating, "Here is a land, tranquil in its quiet beauty . . . with special plant and animal life that distinguishes this place from all others in our country." Naples was conveniently close to the 460,000-acre park, and by 1949, four new motels and several trailer parks had been built along the Tamiami Trail to host a new, traveling public anxious to see alligators and other strange denizens of the Everglades. (Courtesy of Nina Heald Webber.)

By 1954, cypress loggers and developers were encroaching on the last stand of virgin bald cypress in southwest Florida. The threatened Corkscrew Swamp was successfully acquired by the National Audubon Society, but the remote site, completely inaccessible by car, attracted only die-hard hikers until a road was built in 1959. A gatehouse opened in January 1960, and a 5,600-foot boardwalk through the scenic swamp offered an easy way for families to see the giant trees, some more than 700 years old. Birdwatchers flocked to see the sanctuary's famed wood stork nesting grounds, and in the first four months of 1960, more than 7,000 people visited the sanctuary.

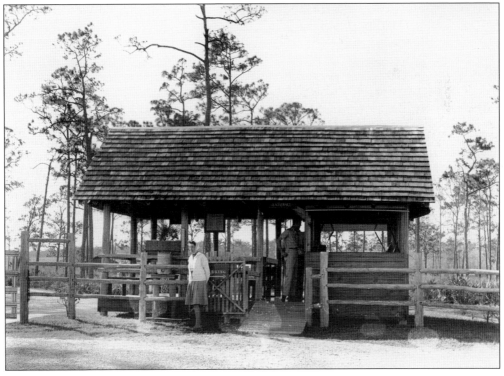

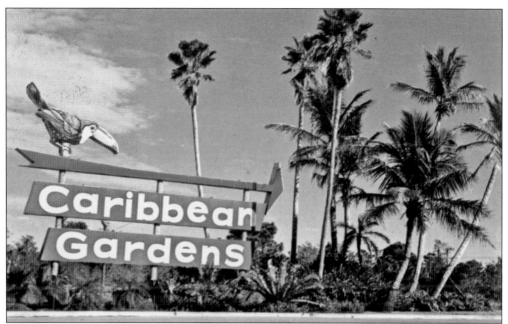

The languishing tropical garden of renowned botanist Dr. Henry Nehrling was bought by Julius "Junkie" Fleischmann in 1951. The wealthy entrepreneur began an extensive restoration of the 30-acre site, adding paths, boardwalks, lakes, and tropical plants from around the world. His Caribbean Gardens opened in February 1954 and by the early 1960s also featured a large collection of free-roaming waterfowl and the internationally famous "Duck Vaudeville" performers, starring Arturo, the piano-playing duck, pictured below. During a 1962 promotional tour, the ducks performed throughout Europe, and Arturo was filmed by French television crews while playing his "wacky quacky rhapsody" on the Champs Elysees in Paris. (Courtesy of Nina Heald Webber.)

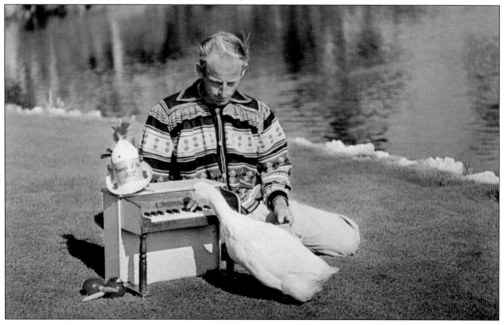

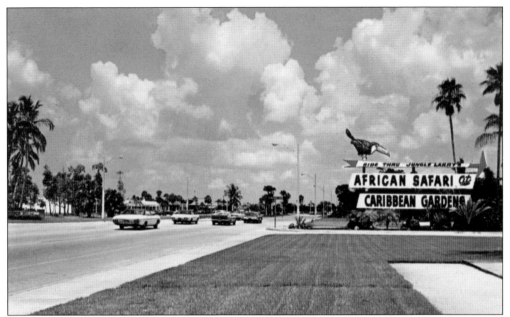

In 1969, Lawrence Erskin "Jungle Larry" Tetzlaff, leased Fleischmann's Caribbean Gardens and renamed the popular tourist attraction Jungle Larry's African Safari. The landmark sign on the Tamiami Trail North, installed by Fleischmann in 1958, was changed, and exotic animals were added to the exhibition gardens. (The sign was torn down in November 2005.) Tetzlaff also owned a zoological park in Sandusky, Ohio, and was star of his own television show, *Animal Safari*. He began his career as a herpetologist, working with wild animal trapper and filmmaker Frank "Bring 'Em Back Alive" Buck. Right, Jungle Larry poses with an 11-foot South American boa constrictor. (Courtesy of Nina Heald Webber.)

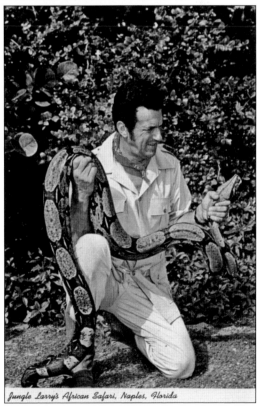

Jungle Larry's African Safari, Naples, Florida

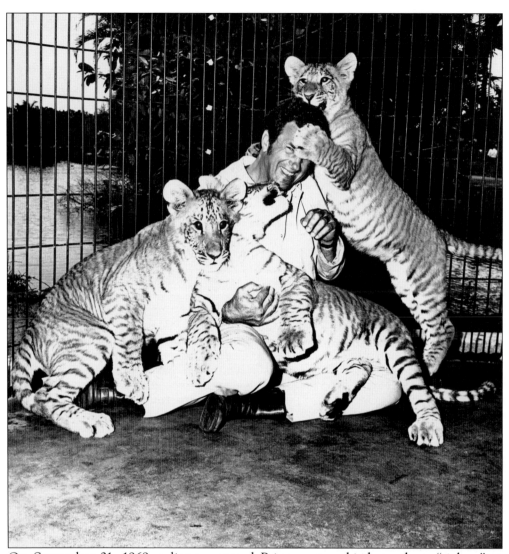

On September 21, 1969, a lioness named Princess gave birth to three "tiglons" at Lawrence "Jungle Larry" Tetzlaff's zoological park in Ohio. The rare tiglons, fathered by a tiger named Rajah, were featured on NBC's *Today Show* just five days after they were born. The cubs were eventually moved to Naples and became a major tourist attraction. According to the March 1973 "Visitor's Edition" of the *Naples Daily News*, Tetzlaff and his wife, Nancy Jane "Safari Jane," were "dedicated to preserving and breeding many of the world's rarest animals." The report noted that Tetzlaff had learned to handle "everything from anteaters to zebras," and also did stand-in and stunt work for Johnny Weissmuller, wrestling real alligators for the Tarzan movies filmed at Silver Springs, Florida.

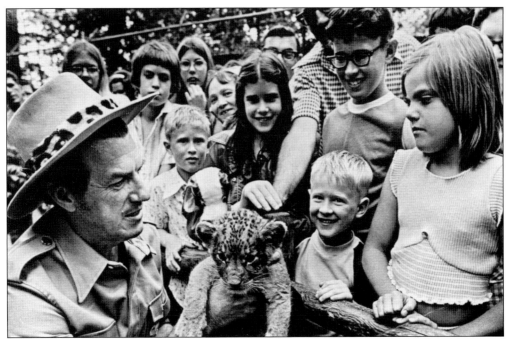

According to a note scrawled on the back of this early 1970s *Naples Daily News* photograph, "Jungle Larry holds a six-week-old, 18-pound lion cub. He shares his world-wide safaris every Monday morning on WEVU-TV, channel 26." In 1973, talk show personality Bill Gordon complimented the internationally known zoologist and entertainer, saying, "All that Frank Buck and Clyde Beatty ever hoped to be, Jungle Larry is."

Lawrence "Jungle Larry" Tetzlaff's wife, Nancy Jane, dubbed "Safari Jane," was also a trained wild animal handler and assisted with the zoological park's animal shows and educational programs. According to a March 6, 1973, article in the *Naples Daily News*, "The wife of TV's Jungle Larry is a qualified herpetologist, and has a 20-foot python as a personal pet. His name is 'Hissing' and he can be heard hissing from 50 feet away." (Courtesy of Nina Heald Webber.)

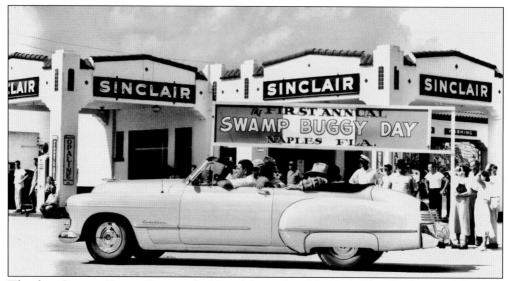

The first Swamp Buggy Day was held on November 12, 1949. The day-long celebration of the strange swamp-striding machines, invented in Naples by Ed Frank, included races and a parade down Fifth Avenue South led by city officials. Pictured above in the lead car, with the northwest corner of Four Corners visible in the background, are, from left to right, driver Wink Clack, Councilmen Pitt Orick and Claude Storter, City Manager Fred Lowdermilk, and Councilmen Rex Lehman and Lige Bowling. (Courtesy of the Florida State Archives.)

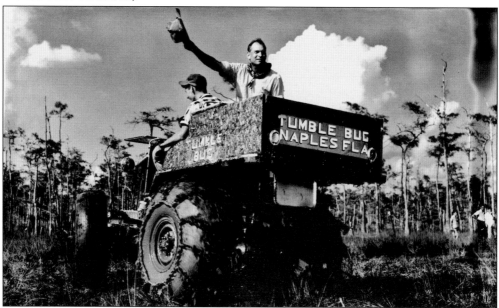

Above, on the left, Paul Frank, son of swamp buggy inventor Ed Frank, drives Tumble Bug during the second annual Swamp Buggy Day race, October 28, 1950, as Henry Espenlaub waves to the crowds. The racecourse was located two miles east of the Naples Airport, and according to the *Collier County News*, the muddy track "can be likened only to butterscotch pudding in looks and consistency." (Courtesy of the Florida State Archives.)

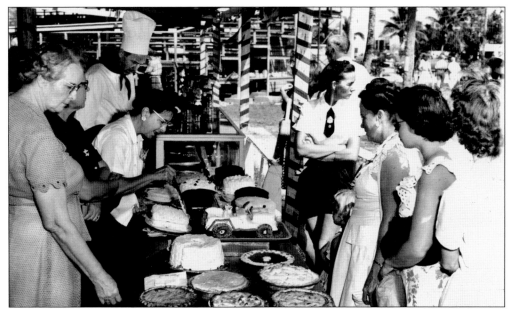

Festivities during the second annual Swamp Buggy Day, held on October 28, 1950, included a baking contest held at Cambier Park. According to the *Collier County News*, special awards were given to Mrs. Harley Chesser for her "Leaping Lena swamp buggy cake [visible in the center of this photograph] and Dr. Jim Craig for his cupcakes, topped with adhesive tape, bandages and medicine droppers." (Courtesy of the Florida State Archives.)

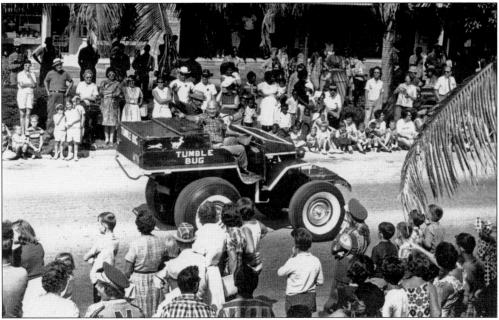

Tumble Bug, with an unidentified driver, is on Fifth Avenue South during the 1966 Swamp Buggy Day parade. An editorial in the *Collier County News* claimed swamp buggies were "as important to Florida as the cow pony is to the west, in that they are the only practical means of transportation once off the main road."

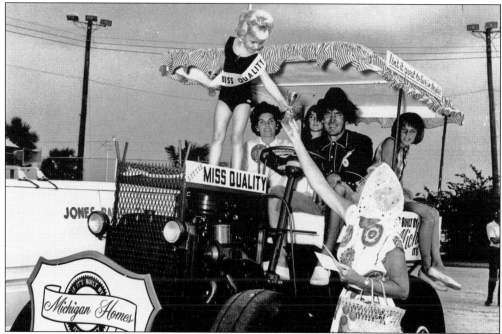

Above, Michigan Homes' "Little Miss Quality" accepts the award for second place in the decorated swamp buggy division of the October 31, 1965, Swamp Buggy Day parade. More than 10,000 people attended the parade, heralded in the *Collier County News* as the "biggest ever." The two-hour parade included 162 vehicles, 63 swamp buggies, 32 horses, marching bands, and clowns.

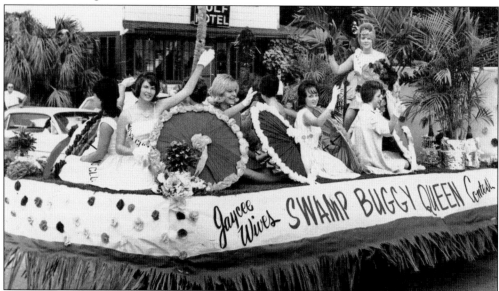

In 1965, 31 young women competed for the title of Swamp Buggy Queen. The winner, Charlene Iamurri, received a $100 savings bond and "a once-in-a-lifetime opportunity to be dunked in the mud by the grand winner of the races," reported the *Collier County News*. The report also noted, "LaVerne Hladek of LaVerne Howard Coiffures has offered to rebuild the royal hair-do following the big dunk."

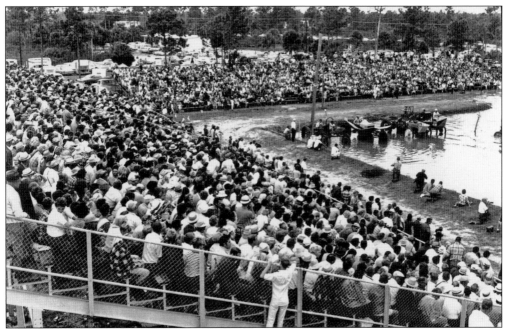

The "Mile-O-Mud" track was carefully groomed before each race, and in 1965, Joe Belyen, president of Swamp Buggy Days, Inc., claimed, "The track is gooier than ever. We've been pumping water into it for a week. The holes are there too, but nobody knows where they are, so it's in really good shape." The track was once part of Raymond Bennett's potato farm, and according to swamp buggy inventor Ed Frank, "it was the boggiest hole in the vicinity of Naples." Below, a west-facing aerial view of the track, dated February 2, 1975, shows the figure-eight course on the left. On the far right is Radio Road.

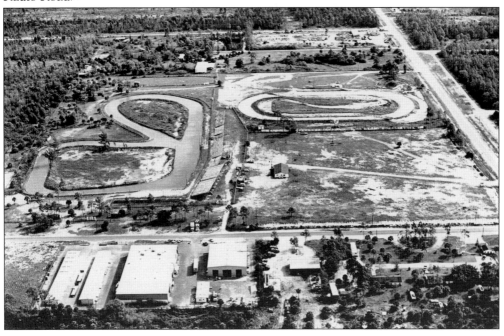

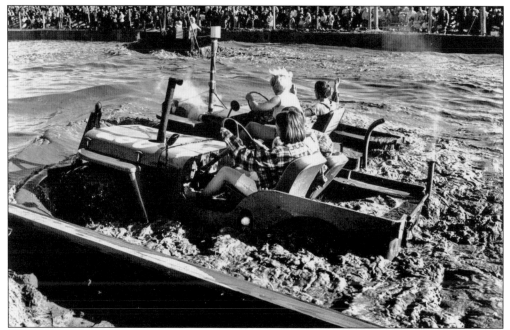

"The Powder Puff Derby is the wackiest race of all. That's when the women drivers get the road all to themselves," reported the *Collier County News* on Swamp Buggy Day, October 31, 1965. Elizabeth LaRoss of Miami, driving her rig, Yee Haw, won the 1965 title of Mud Duchess by defeating Linda Barnhart driving Hootenanny.

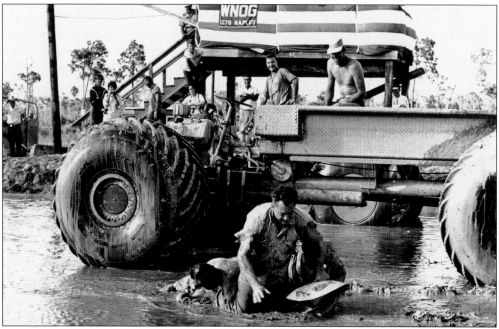

By the early 1960s, mud baths were a traditional part of what promoters called the "dirtiest race in the world." In 1965, Mayor Archie Turner had the honor of dunking the overall winner of the Swamp Buggy Day races, Jack Hatcher. The new Swamp King then ceremonially dunked the Swamp Buggy Queen, Charlene Iamurri.

Five

THE WINDS OF CHANGE

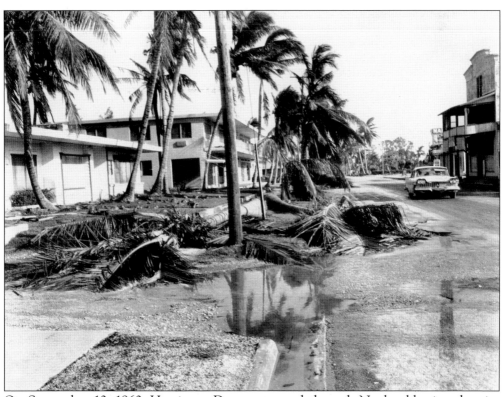

On September 10, 1960, Hurricane Donna stormed through Naples, blasting the city with wind gusts estimated to be more than 160 miles per hour. Five days later, the *Collier County News* reported, "Donna—vicious windy beast that she was—will be the classic of hurricanes in comparisons drawn in future years." Damage to the city was estimated at $25 million. Above is Third Street South, looking north, after Hurricane Donna.

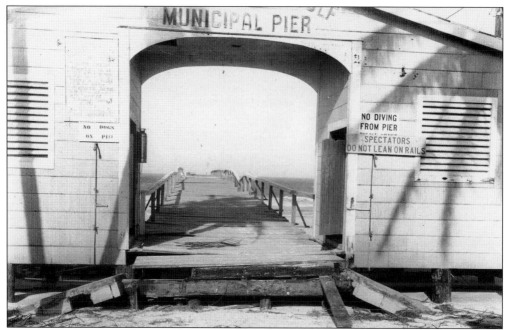

Five days after Hurricane Donna, the *Collier County News* issued a special hurricane edition, reporting, "Shocked, numbed residents of Naples and other parts of Donna-smashed Collier County are gradually recovering from the cruelest nature-born blow in the history of this frontier land." The front page included a photograph of the destroyed municipal fishing pier, captioned, "Pride of Naples, gone with the wind." The special edition was printed by the *Fort Myers News-Press* since the newspaper's presses were ruined after a four-foot storm surge flooded the Crayton Cove office and printing plant. The hurricane edition noted that the storm surge also "rolled eastward at four-foot heights, capsizing shacks and trailers, and ruining many homes that remained standing." Below, clean-up begins on Fifth Avenue South.

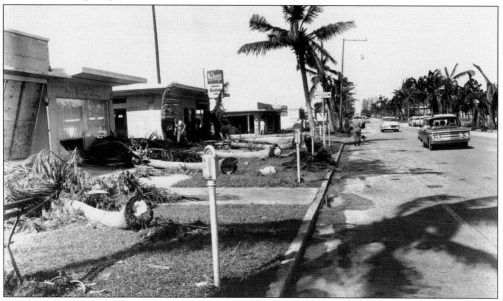

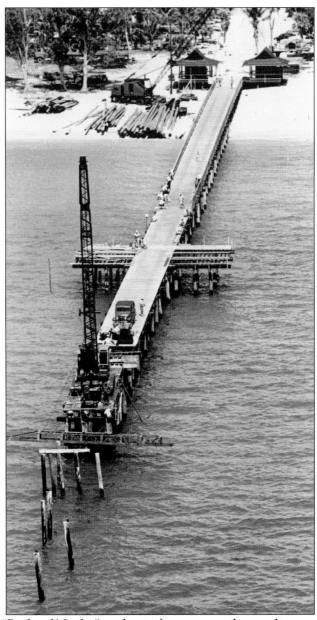

Rebuilding the "Pride of Naples" took nearly a year, and according to the July 2, 1961, special fishing pier edition of the *Collier County News*, "With Donna constantly in mind, the job had to be done better than ever before." The new pier, which measured 1,002 feet and 1 inch, was constructed of rot-resistant "greenheart" pilings and was designed to withstand winds of 175 miles per hour. Architects Ralph and William Zimmerman designed Tahitian-style buildings for both the new pier and nearby Lowdermilk Park. An estimated 5,000 people attended the dedication ceremony on July 4, and festivities included a boat parade, water safety demonstrations, a water skiing show, and fireworks. Naples philanthropists Lester and Dellora Norris donated more than $125,000 to the city to rebuild the pier, since "ironically, insurance on the pier had been cancelled a few short weeks before Donna struck," reported the *News*.

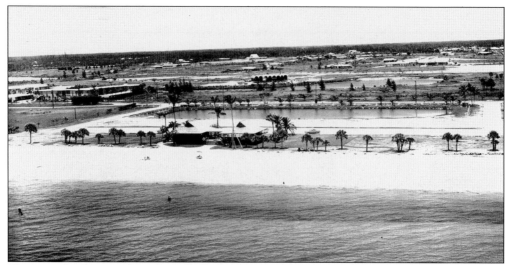

The new facilities at Lowdermilk Park, designed by pier architects Ralph and William Zimmerman, were dedicated on July 4, 1961, just hours after the rebuilt pier was officially dedicated. The park was named after Fred Lowdermilk, who served as the Naples city manager from 1949 to 1961. The caption for the undated, c. 1961 *Collier County News* photograph above noted, "The body of water directly in the rear of the park is not a swimming pool; it is a natural 18-foot deep pond and legend has it that an alligator calls it 'home.'" According to *Tales of Naples . . . Some of Which are True*, the concrete fence visible in the foreground in the photograph below was originally part of the railing from the Gordon River bridge.

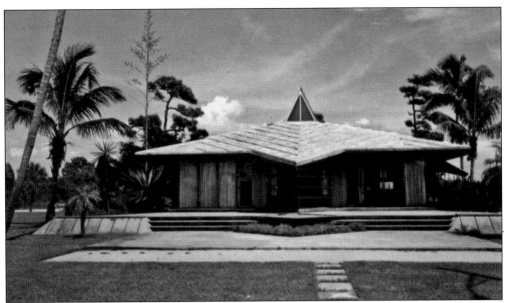

The Tahitian-style buildings designed for the new fishing pier and Lowdermilk Park inspired similar designs throughout Naples, including the new Naples Chamber of Commerce building, designed by architects Don Nick and Richard Morris. The eye-catching, star-shaped building, located on the north Tamiami Trail, just south of the entrance sign to Julius Fleischmann's Caribbean Gardens, opened in April 1961. Fleischmann owned the building and charged the chamber $1 per year for its use. (Courtesy of Nina Heald Webber.)

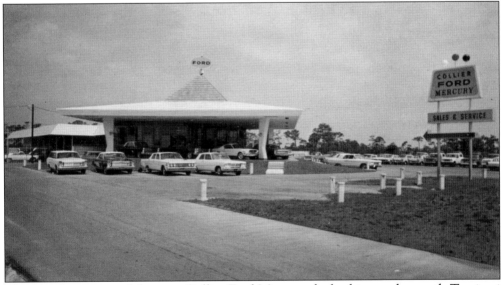

The grand opening of the new Collier Ford Mercury dealership on the north Tamiami Trail was held on April 16, 1965. The *Collier County News* included a front-page story of the event noting, "a continuous line of visitors were attracted by Bob Baroni's roast beef buffet." On the back of this *c.* 1965 postcard, salesman Bob Smith wrote to a prospective buyer, "I'll save you $100 a minute dealing with me on a new Ford of your choice." (Courtesy of Nina Heald Webber.)

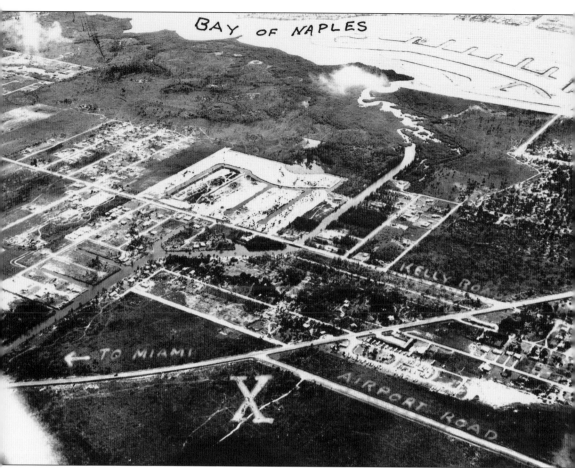

BAY OF NAPLES

KELLY ROAD

← TO MIAMI

X

AIRPORT ROAD

" 'X' marks the spot" captioned this January 14, 1960, photograph featured on the front page of the *Collier County News*. The X marked the location of the future Collier County Courthouse and Government Center. Founded in 1923 and named after Barron Gift Collier, the county's first seat was located in Everglades (now Everglades City), in the southern part of the county. By the late 1950s, the center of the county's population had shifted to Naples, and the Naples Junior Chamber of Commerce sponsored a petition to relocate the county seat to Naples. Although voters approved a move to east Naples in 1959, opponents successfully stalled the move with a series of lawsuits until January 1961. Construction began at the new site, at the junction of the Tamiami Trail and Airport Road, in October 1961. Less than a year later, the county commissioners held their first meeting in the new facility on September 4, 1962.

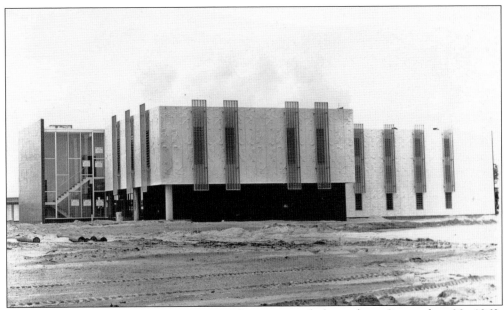

The new Collier County Government Center was dedicated on September 30, 1962. The complex included four buildings housing the courthouse, jail, county offices, and health department. According to an August 13, 1965, report in the *Collier County News*, "The $1,600,000 compound has a most unusual bas relief art form in three dimensions decorating the exterior. These abstract designs represent the Seminole Indians (early settlers of the area), as well as various phases of government. The courtroom, sheriff offices and the jail are located in the main two-story building." (Below courtesy of Nina Heald Webber.)

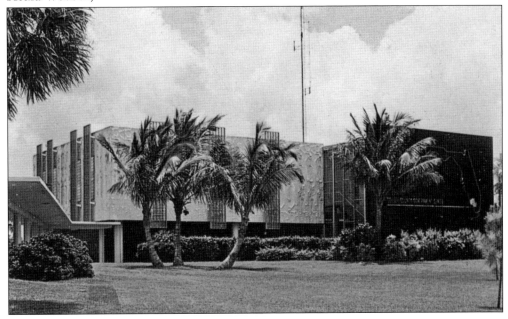

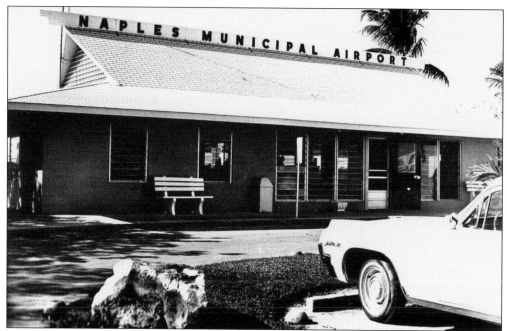

The Naples Airport was built during World War II as a training base for Army Air Corps fighter pilots. After the war, the 659-acre facility was given to the City of Naples and Collier County. The city bought out the county's share in 1951, paying $8,311 for the facility. The mayor at that time, W. Roy Smith, reminisced during a 1990 interview with the *Naples Daily News* that he was "chewed out for throwing taxpayers' money away." By 1957, the first scheduled air service was offered by Naples Airlines/Provincetown Boston Airlines. A new terminal building was added in the early 1960s, built in the popular Tahitian style. Below, the new terminal building is visible in the center of the photograph in this east-facing view of the airport.

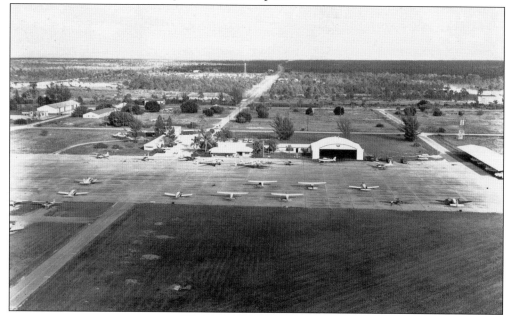

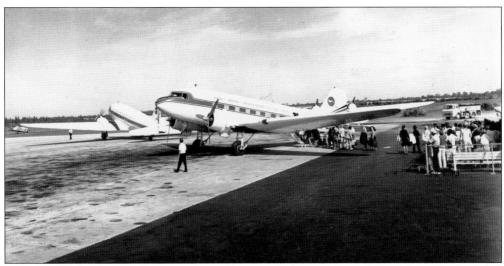

In 1960, Naples Airlines/Provincetown Boston Airlines provided charters and scheduled service to and from Miami during the winter tourist season. During the summer of 1961, the small airline also began offering sightseeing trips as part of Gulf American Land Corporation's promotion of their new development, Golden Gate. By 1962, three sightseeing trips were offered daily, and potential buyers enjoyed complimentary transportation to Naples, a free 20-minute flight over the development area, and lunch in a Naples restaurant. According to a report in the January 14, 1962, *Collier County News*, "Thousands of visitors have come to Naples over the past few months as part of the Golden Gate Estates sales program." Eventually, the airlines added several DC-3 aircraft to their commuter fleet. Below, the city of Naples is visible in the distance in this southwest-facing view of the airport.

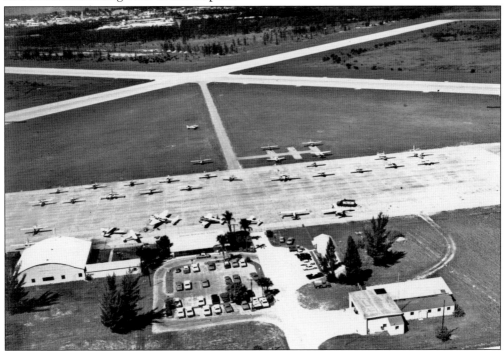

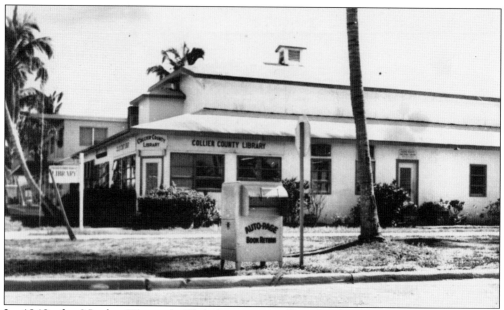

In 1948, the Naples Woman's Club began to collect books for a free public lending library, and by 1958, more than 7,500 volumes crowded the shelves in the club's new Cambier Park clubhouse. One year later, the group gave their large collection to the county, and in 1962, the library was moved to the old Naples Company building on the corner of Third Street South and Broad Avenue South.

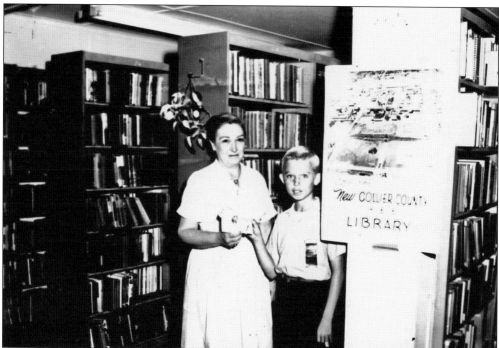

Librarian June Haschka (left) accepts a donation for the new Collier County Free Library building fund from David Miller in this c. 1964 photograph. By 1965, the Friends of the Library had raised more than $86,000 for construction of a new library building.

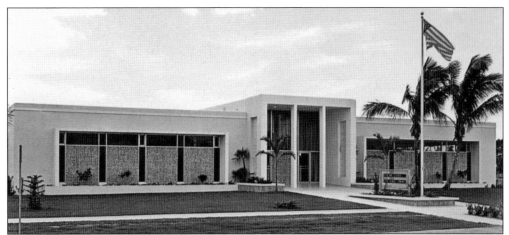

On July 10, 1964, Dr. and Mrs. Ferdinand C. Lee deeded to the Friends of the Library the city block facing Central Avenue, between Sixth and Seventh Streets South, "to have and to hold the same in fee simple forever; provided that said land shall be forever used only for public library purposes." Naples architect Clarence M. Bauchspies designed the building, which was formally dedicated on February 13, 1966. In addition to a ribbon-cutting ceremony with county officials and Congressman Paul G. Rogers, Mrs. June Haschka, librarian, conducted a special flag-raising ceremony. Music was provided by the Naples High School Band. (Courtesy of Nina Heald Webber.)

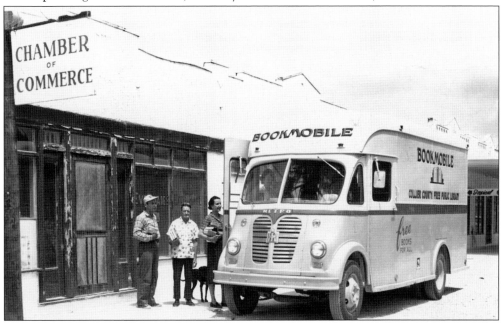

"A bookmobile, one of the first in southwest Florida, has for several years made regular visits throughout the county to make available reading material to those who could not easily come to the main library in Naples," noted an editorial in the February 13, 1966, edition of the *Collier County News*. The editorial continued, "It will, of course, continue to make these visits, but now it can offer a wider variety of reading material with the opening of the new library." The bookmobile visited eight remote county communities, including Everglades, featured in this *c.* 1965 photograph.

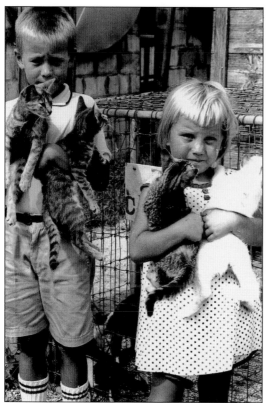

In March 1952, the city's first dog pound was built with "two compartments, one for male and one for female dogs," reported the *Collier County News*. There were no facilities for stray cats, and in 1962, the newly formed Humane Society of Naples began a fund-raising campaign to build an animal shelter in Naples. In February 1962, a month after the pound began accepting stray cats, the children of Humane Society president Lori Keller Stuber, Michael Keller, age 7 (left), and Nancy Keller, age 5, posed in front of the cages, holding 4 of the 25 cats available for adoption. Soon after this photograph ran in the *Miami Herald*, the City of Naples offered a building site on the east side of the city's airport. On March 31, 1963, more than 500 people attended the official opening of the new shelter, pictured below, where 30 homeless dogs and cats, and a "lone pigeon with a bracelet on its foot," were already waiting to be adopted. (Both courtesy of Lori Keller Stuber.)

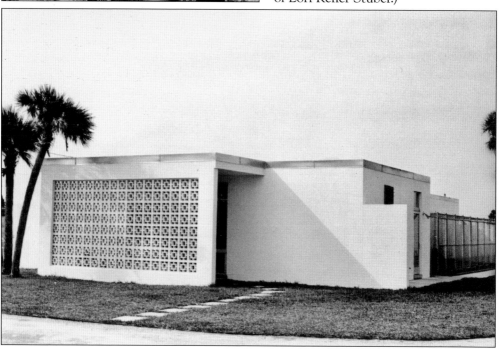

During the early 1960s, self-made millionaire John Slater created his own nature center on the grounds of his gulf-front Gordon Drive estate. Pictured on he right with his miniature Argentinean horse, Slater collected a wide assortment of exotic animals, including a cheetah, Australian wallabies, kangaroos, ostriches, and deer. Sea turtles, seals, and dolphins, including Flipper's sister, Flash, lived in a special saltwater pool on the estate. Slater offered free tours to school groups and, in 1969, opened his estate as a fund-raiser for the Humane Society of Naples. Below, a pre-event publicity photograph shows Humane Society officers at Slater's pool, including, from left to right, Lori Keller, president; Linda Condon, treasurer; and Sandy McLeod, secretary.

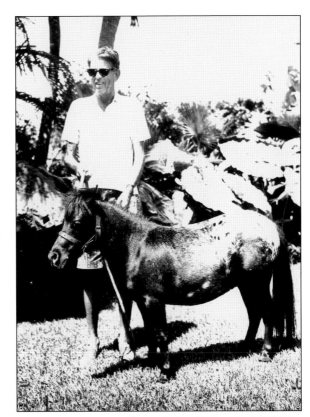

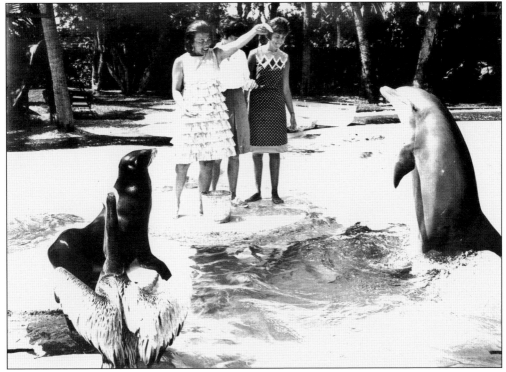

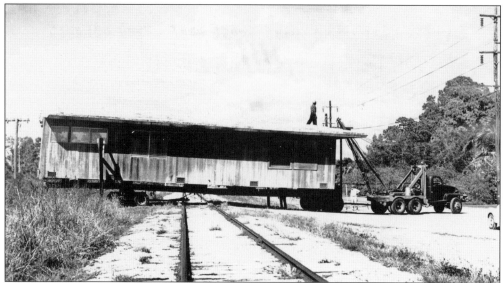

"Fleischmann Donates Home! We're getting rare nature center," headlined the front page of the December 17, 1959, issue of the *Collier County News*. Just a few weeks later, Julius Fleischmann's 15-room beachfront estate was cut into five sections and moved two miles to a five-acre site, also donated by Fleischmann, just north of Caribbean Gardens. His former home became the Big Cypress Nature Center, an affiliate of the Nature Centers for Young Americans, Inc.

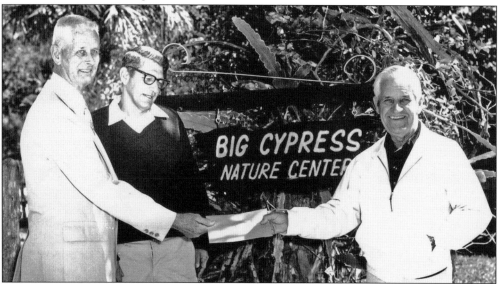

In 1976, the Big Cypress Nature Center merged with the Collier County Conservancy, becoming the education division of the conservation organization. By 1979, a new 13-acre site to the south of Caribbean Gardens had been acquired, and plans were unveiled for a $1.25-million nature center complex. On March 6, 1979, this photograph was featured in the *Naples Daily News*, captioned, "Prosser Speer, Naples Shell Club president, left, gives Willard Merrihue, president of the Collier County Conservancy, a check for $22,000. Second from left is Dr. Gary Schmeltz, director of the Big Cypress Nature Center."

In 1967, Sinclair Oil congratulated "The town that put up the fight of its life—for its wildlife," in a series of national magazine advertisements. Three years before, concerned citizens had formed the Collier County Conservancy to stop the construction of a road through the heart of Rookery Bay, an unspoiled bird nesting area and prime fishing ground just south of Naples. The road project was successfully delayed, and to permanently protect the bay, the conservancy began a campaign to create the Rookery Bay Sanctuary. A purchase agreement for 1,600 acres was signed in October 1965, and the *Collier County News* reported: "In a re-enactment of an age-old ceremony of land transfer, a group of officials went by boat to Sand Hill, a unique elevation in the mangrove forest. Representing the present owners, Gene Parker broke a twig from a gumbo limbo tree and picked up a handful of sand, which he transferred to the hands of officials of the Conservancy. Now the group needs to raise $270,00 to acquire title and assure permanent stewardship." More than 1,400 citizens and 20 civic groups donated to the Rookery Bay fund, and the Rookery Bay Sanctuary was established in 1966. (Courtesy of Nina Heald Webber.)

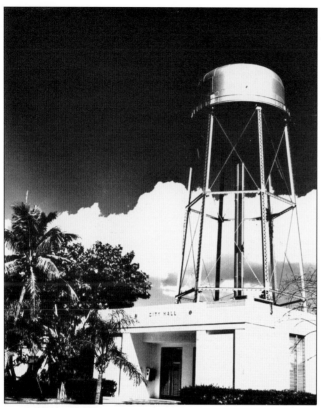

"A familiar landmark in Naples is this 250,000 gallon water tank at the City's water plant, over City Hall," noted a report in the April 5, 1957, edition of the *Collier County News.* The report continued, "The tank soars to a height of 140 feet, is 40 feet in diameter, cost about $25,000 to erect, and acts as a 'float' on a distribution system spilling out water at a current rate of 300,000,000 gallons a year. It was erected in late 1945 and put into service in early 1946." By 1975, plans for a new city hall called for the removal of the tower at an estimated cost of $100,000. It was demolished in 1978. Below, the landmark tower *c.* 1965, with "City of Naples" painted on the sides, is visible on the left of this southwest-facing view of Ninth Street South.

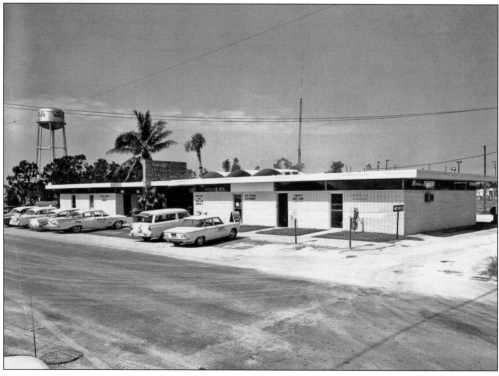

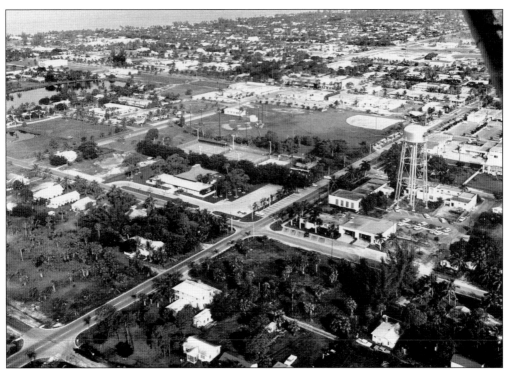

On August 22, 1963, plans were unveiled for a new $60,000 recreation center on Eighth Street South, on the southeast corner of Cambier Park. Architect William Wallace Zimmerman, one of the designers of the Tahitian-style buildings on both the pier and at Lowdermilk Park, designed a similar building for the new center in a style dubbed "Neapolynesian" by the *Collier County News*. Above, in this October 1965 aerial, the recently completed recreation center is visible in the left center. Less than a year later, the new children's play area, Candy Cane Park, visible below, opened on the park grounds.

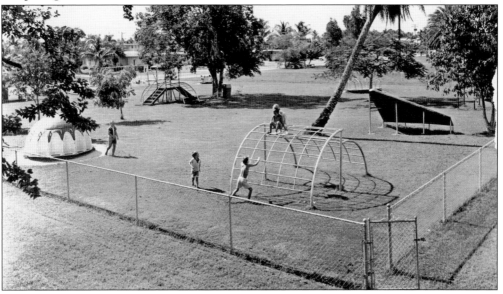

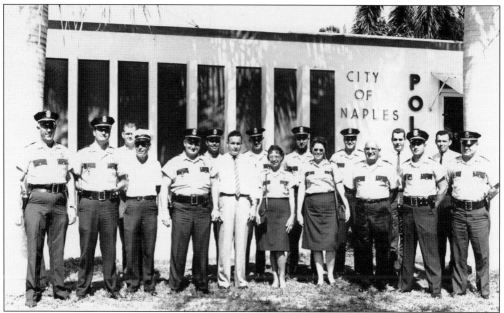

Seventeen of the 19 members of the Naples Police Department posed in front of the police building on Eighth Street South in this *c.* 1965 photograph. From left to right are acting Chief of Police Sam Bass, Sgt. Robert D. Alexander, Barrie Kee, Emmett Pound (meter man), Freeman Wood, Chester Keen, Richard Davidson, Kenneth Mulling, Dorothy Koester, Sgt. Charles E. Jones, June Holzhausen, Lt. Jack Bliss, Nick Triffiletti, Mike Grimm, George Dampier, Gary Young, and C. H. Dasher.

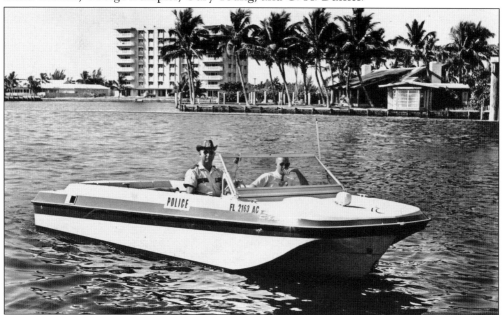

Sam Bass was appointed chief of police in May 1965. In his annual report for that year, he noted the force had investigated 3,281 complaints. In addition to patrolling Naples Bay aboard the police boat, pictured above, officers also patrolled a total of 162,964 miles and made 107 arrests for drunkenness. One homicide was reported for the year.

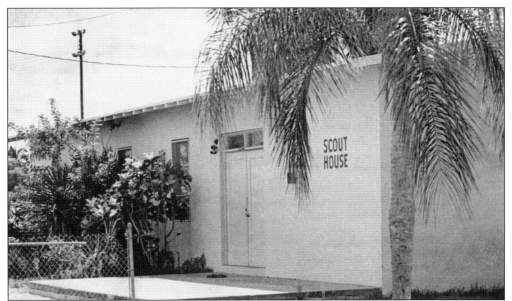

Construction of the Naples Scout House in Cambier Park began in early 1957, and according to a report in the February 8, 1957, edition of the *Collier County News*, "The building, a project of the Naples Rotary, will be used by all scout units when it is completed in the near future. The spacious interior has a stage at one end for ceremonies." The building was dedicated in May 1957.

Written on the back of this undated, late-1960s photograph is "Brownie Troop 137 meets with Dr. Earl Baum for talk on nature." Dr. Baum, an avid hunter and fisherman, attempted to collect one of every different kind of bird, fish, reptile, and mammal in Collier County. He eventually collected more than 180 specimens, which were displayed in a specially designed trophy room in his Naples house. In this photograph, a few of the girls are holding postcards of a 1,200-pound manta ray caught by Dr. Baum in 1938.

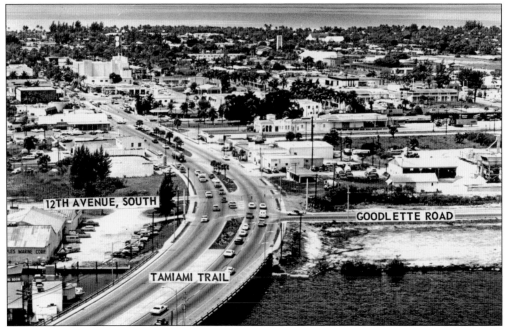

Scrawled on the back of the c. 1969 photograph above is "A real bottleneck." An ever-increasing number of winter season and year-round residents were flocking to Naples, and a March 8, 1966, editorial in the *Collier County News* asked, "With Naples one of the fastest growing communities in the United States, how can even faster growth be accommodated and still conserve the qualities and features of the Naples way of living, which fundamentally are the root cause of Naples' growth?" Above, a west-facing view of the Tamiami Trail, with Four Corners visible in the upper left, shows the development along the increasingly busy thoroughfare. (Note the mislabeled "12th Avenue, South," actually Twelfth Street South.) Below, a south-facing view of Naples Bay is dated December 1, 1969.

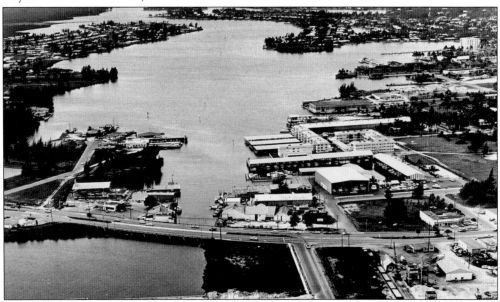

Six

"It's Great to
Live in Naples!"

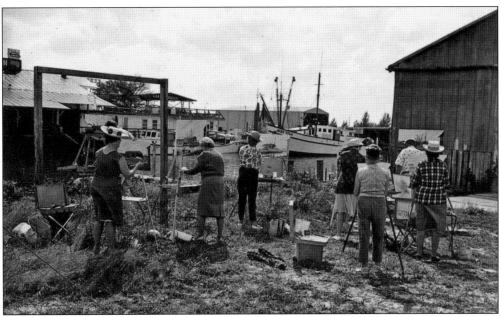

"Yankee, don't go home! . . . Certainly not before it's absolutely necessary. Come back next year—and plan to stay!" implored a March 1966 real estate advertisement in the *Collier County News*. Beautiful beaches, balmy winter weather, and new cultural amenities attracted a growing number of both seasonal and year-round residents, and the caption on the back of this postcard, mailed in 1968, invites, "Join the fun. It's great to live in Naples!" The fish house to the right of the painters became part of the Old Marine Marketplace in 1977. (Courtesy of Nina Heald Webber.)

"Million-dollar 'Co-op' First in Southwest Florida," headlined the front page of the January 22, 1957, *Collier County News*. The new Bahama Club, directly on the gulf, offered four different floor plans, with prices ranging from $31,000 to $39,000. The *News* noted: "Considered the ultimate in luxurious Florida living, the 36-unit beauty took its proud place on the Naples shoreline just five months after the first shovelful of earth was turned in what had been a coastal scrubland. The building is already nearly sold out." (Courtesy of Nina Heald Webber.)

The Moorings development began in 1957 when developer Milton Link, second from the right, purchased 300 acres on the north side of the city. The development eventually encompassed nearly 1,300 acres, including nearly two miles of beachfront. By 1963, the Moorings was the only development in Naples with its own executive golf course and country club, and within five years, the project was almost completely sold out.

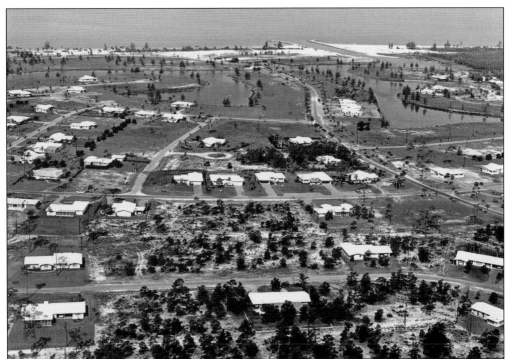

The new rock jetties at Doctor's Pass, built by the Moorings Development Company, are visible on the upper right side of this c. 1960 photograph. Homesites in the Moorings started at $5,500 and ranged up to $9,500 for waterfront lots. In 1963, Michigan Homes began building homes in the Moorings and within two years had built three model homes on Mooring Line Drive, all furnished by Robb and Stucky of Fort Myers. By 1965, the company had built 139 homes in Collier County. Below is a Michigan Homes advertisement from the 1970 Naples High School yearbook. (Below courtesy of Nancy Evans.)

The Beauty of a *Michigan Home* is LIVING IN IT!

Furnished Dispay Models in The Moorings and Lely Estates

You'll Never Regret Buying Quality

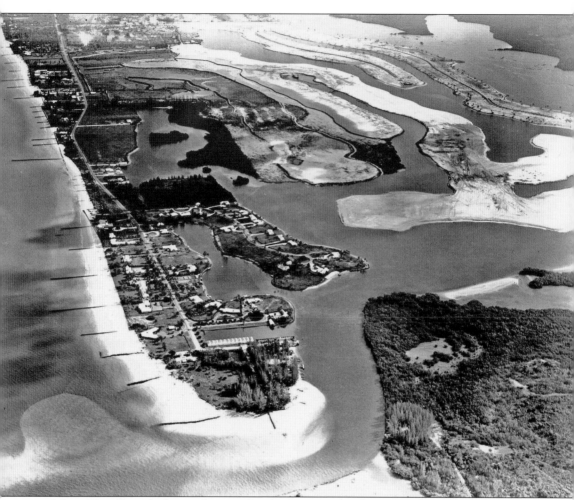

John Glen Sample began buying "useless" swampland just south of the city in 1938. Ten years later, the wealthy advertising executive retired to Naples, and a report in the August 13, 1948, edition of the *Collier County News* noted: "J. G. Sample bought extensive bay front property for $13,700. This purchase, added to his already extensive holdings, make Mr. Sample one of the largest land owners in Naples. He has announced no plans for development, but there have been indications he has something in mind." Sample soon revealed his plans for Port Royal, a luxury waterfront community designed for "desirable purchasers who do not want gambling, horse racing, dog tracks and night clubs as part of their daily life." His dredge and fill development formed serpentine peninsulas out of a swampy mangrove forest, creating 700 building sites—600 fronting deep water. By 1952, three sections had been completed, including Lantern Lake, Cutlass Cove (pictured above, left of center), and all gulf-front property. In this *c.* 1953 photograph, the still-raw, recently created Treasure and Galleon Coves are visible to the northeast of Cutlass Cove.

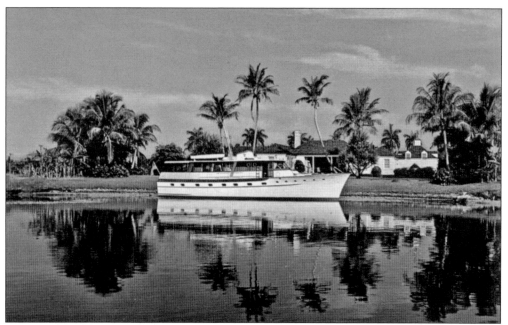

By 1952, four homes had been built and were for sale to "acceptable purchasers at exact cost," announced an advertisement in the *Collier County News*. Prices ranged from $19,999.99 to $45,000 for the "Bermudian Residence" on lot nine, which featured three bedrooms, two tiled baths, and an oversized one-car garage. Building sites ranged in price from $7,500 to $25,000. Prospective buyers toured the community in Sample's Rolls-Royce Silver Cloud or onboard his 70-foot yacht, *Privateer IV*, pictured above. Below, the new Port Royal sales and administration building was completed in 1971. (Above courtesy of Nina Heald Webber.)

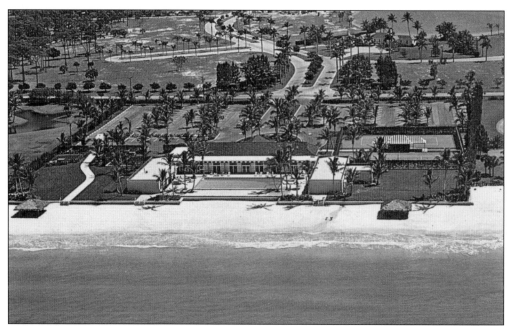

Port Royal developer John Glen Sample controlled virtually every aspect of the community, setting strict architectural codes and requiring mandatory membership in the private Port Royal Beach Club, pictured above and below, indicating to prospective buyers that all residents would be hand-picked. The clubhouse, designed by John Volk of Palm Beach, Florida, was completed in 1960 and by 1968 included an Olympic-sized swimming pool, putting green, tennis courts, lounge, card room, lockers, and "superb dining facilities, maintained all year, not just during the season," noted a *Collier County News* advertisement. (Above courtesy of Nina Heald Webber.)

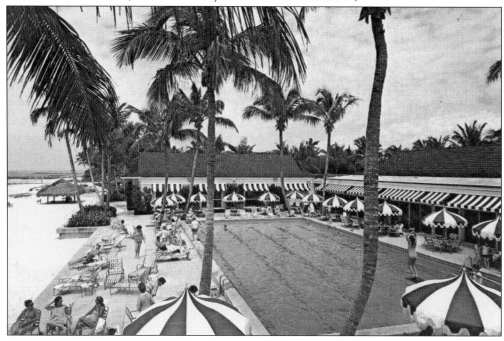

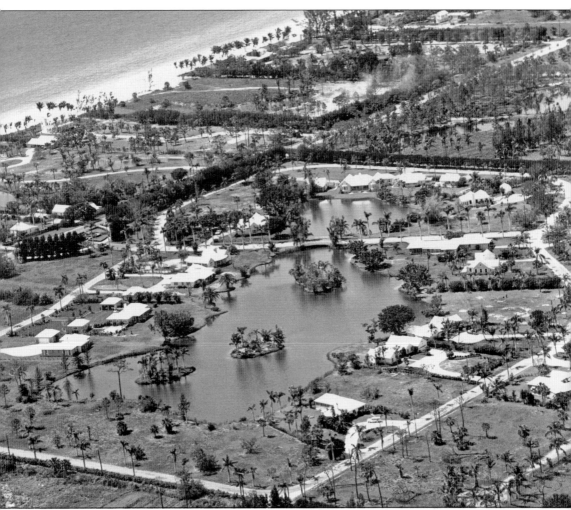

By 1952, three sections had been completed in John Glen Sample's Port Royal, including Lantern Lake, pictured above. Serpentine streets and lush landscaping were designed to "make Port Royal one of the beauty spots of the American Tropics," noted a 1952 advertisement in the *Collier County News*. The full-page advertisement continued: "The Port Royal plan was executed by Howard Major, architect, Palm Beach, Florida, who is nationally known and recognized as one of the outstanding architects in the United States. A standard has been set for the appearance of the houses to be built. Without such protection, it would be in the power of the individual lot owner to mar the excellence of the whole undertaking." No duplication of plans was permitted. By 1968, 208 homes had been built, and small green signs were placed on still-available lots, listing the full dimensions of the property. An advertisement recommended, "You must drive out on the property to appreciate the water view."

The Naples Company offices, built c. 1921 on Third Street South, also served as the town's first community church. By 1950, five churches were established in Naples, although only three had their own building, including the First Methodist Church, on First Avenue South, (pictured above) and the First Baptist Church, on Eighth Street South next to City Hall, (pictured below). According to the February 1950 church listing in the *Collier County News*, the Church of God was located "one block east of the Tamiami Trail," the Episcopal church was temporarily located in the dining room of the Naples Beach Hotel, and the Catholic church met in the Naples Theater on Third Street South. (Courtesy of Nina Heald Webber.)

FIRST BAPTIST CHURCH NAPLES FLORIDA 13

In the spring of 1951, a new Episcopal church, Trinity-by-the-Cove, was completed in Port Royal. A February 1952 advertisement in the *Collier County News* noted, "The church is an agreeable edifice in the colonial style, built on the triangular site at the intersection of Galleon Drive and Treasure Lane." Below, the caption on the back of this postcard, mailed in 1964, states, "The church, Parish House, and Rectory adjacent to Jamaica Channel, with the Gulf of Mexico in the background." (Courtesy of Nina Heald Webber.)

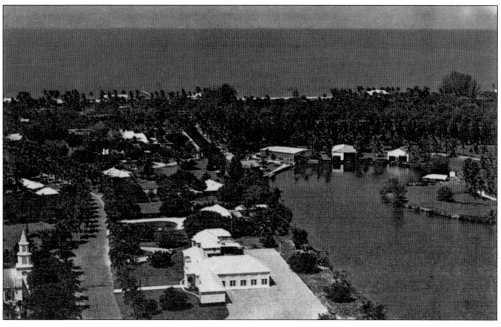

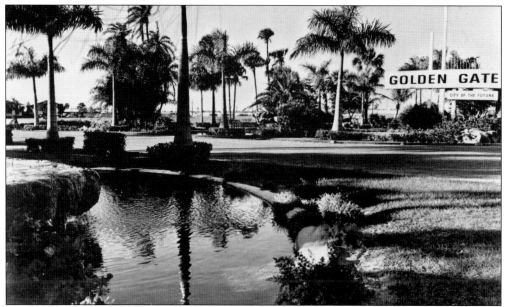

On March 24, 1965, Collier County commissioners attended a dedication ceremony at the new Golden Gate City, celebrating the occupancy of the first nine homes in the community. Gulf American Land Corporation, developer of Cape Coral in Lee County, began work on Golden Gate City in 1962, and three years later, the *Collier County News* reported, "Although still in its infancy, the eight-square-mile community already features an airport, a championship golf course and 'posh' country club [visible below], a model home village and centralized water and sewer system." Potential buyers were offered free gasoline, trading stamps and oranges, as well as free fishing, including bait and tackle, free car tours of "modern, elegant Naples," and free airplane rides over Naples and Golden Gate.

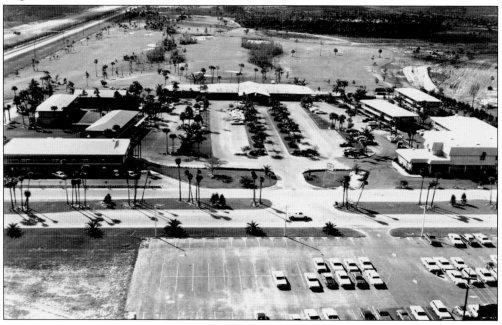

In May 1965, a Golden Gate City home designed by Harold Davis won the *Parents Magazine* "Expandable Home" award, which recognized "home builders who contribute the best design and construction of homes for the particular needs of families with children." Winning designs were required to have at least one expansion possibility that would add architecturally to the appearance of the house. More than 100 people attended the groundbreaking ceremony for the Expandable Home, which became part of the Golden Gate model home village. The five models—Dubonnet, Carillon, Debonair, Dorinda and Cantata— ranged in price from $13,590 to $17,590. Right, the building permit for Walter Partington's home, issued September 12, 1967, is displayed on his homesite. By 1973, more than 548 single-family homes had been built in the city. (Right courtesy of the Collier County Museum, Naples, Florida; Lou Capek Collection.)

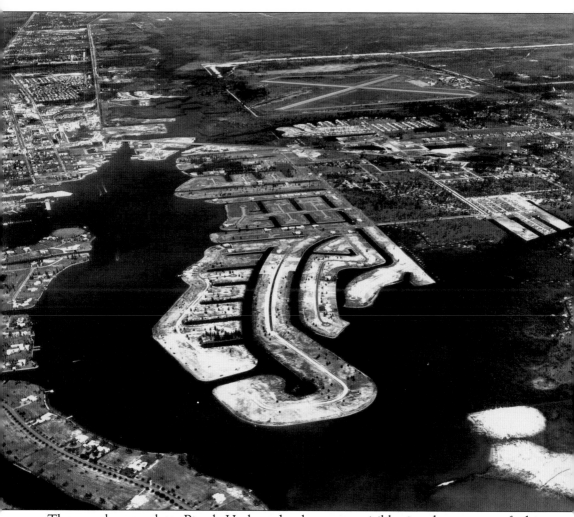

The nearly complete Royal Harbor development, visible in the center of this January 22, 1963, photograph, was begun in the late 1950s by developer Ray Radabough. (In 1957, he shared one of the project's dredges with the City of Naples to help with the dredging of Gordon Pass.) The dredge and fill development on the eastern side of Naples Bay offered buyers fully sea-walled waterfront lots, and by 1964, prices for home sites ranged from $5,400 to $19,900. Advertisements boasted, "Every backyard is bay front" and as an added incentive noted, "For every lot purchaser, Royal Harbor will build a landing dock free of charge, or if you prefer, contribute the same amount toward construction of a slip." Four years later, the development was nearly sold out, and full-page advertisements in the *Collier County News* urged potential buyers to move quickly, since "waterfront sites are disappearing." On the lower left of the photograph is Port Royal, with Aqualane Shores just to the north. The new Naples Land-Yacht Harbor is visible on the far right center of the photograph.

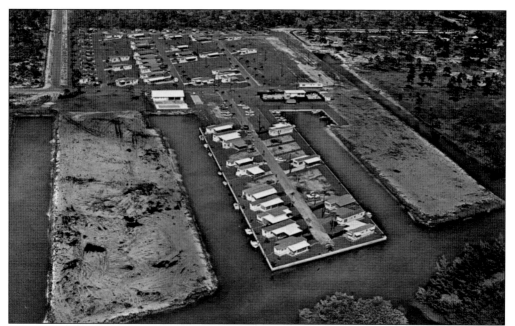

In 1962, the Naples Land-Yacht Harbor, pictured above, opened in east Naples, offering sea-walled waterfront lots and direct access to the gulf. A 1968 advertisement in the *Collier County News* asked: "Want your own place to return to each winter season? With no reservations to worry about or high seasonal rent to pay? Does this sound like a dream? Many retired and semi-retired persons like you have found their answer in mobile home living at Naples Land Yacht Harbor." By 1965, there were 12 trailer parks in Naples, including Harmony Shores in east Naples, pictured below. (Courtesy of Nina Heald Webber.)

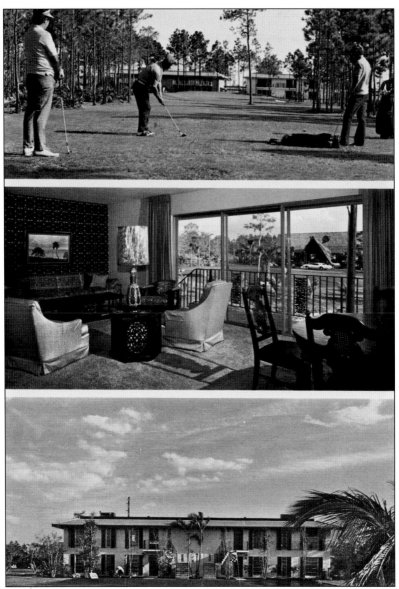

By the late 1960s, condominiums were gaining in popularity, and a 1966 editorial in the *Collier County News* noted: "Twenty years ago, you couldn't give an apartment building away. Today, well over 30 percent of all new construction is apartment units, and where the trend stops, nobody knows." Developers were forced to move north and east of the city, and by the early 1970s, several golf communities were established along the east Tamiami Trail, including the Glades Country Club Condominiums, touted in advertisements as "A great place to swing." These photographs from a c. 1974 promotional brochure showcase the amenities of the development, which included two professionally designed golf courses, a club house with a lounge and color television, a heated swimming pool, tennis, shuffleboard, basketball, and horseshoe pitching. In a 1973 interview, Dudley Gray, a professional golfer and landscape architect for the Glades Country Club noted, "It's a challenge to take a piece of wilderness and make something pretty of it."

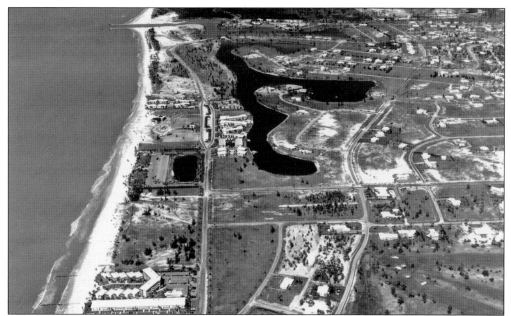

"Startling High-Rise Development in Naples," headlined the front page of the March 8, 1966, edition of the *Collier County News*. The report continued: "Where will Naples' high rise era stop? Five years ago, Gulfshore Boulevard was all but a deserted stretch of sandy beach from the Bahama Club to Doctor's Pass. Today, high-rise co-ops and condos dot the landscape." Above, the angled buildings of the Bahama Club are visible on the lower left of this photograph dated January 22, 1963. To the north is Doctor's Pass, and in the center of the photograph is the Moorings. Below, just south of Doctor's Pass, are new high-rises under construction on Gulfshore Boulevard. In the foreground of this *c.* 1965 photograph is the nearly complete Beacon House, visible on the right center.

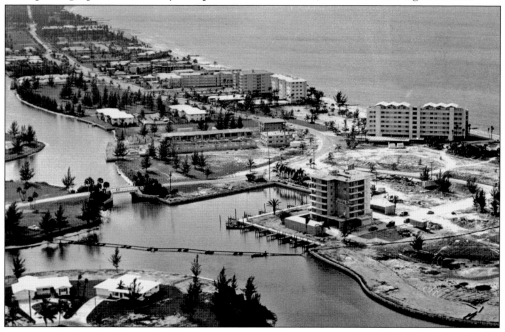

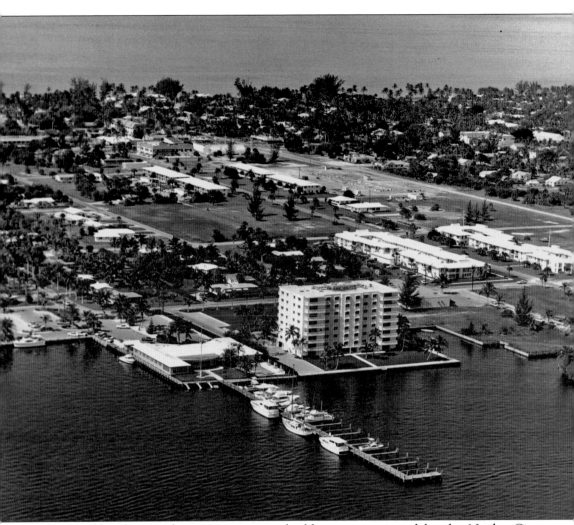

A record-breaking eight-story apartment building was approved by the Naples City Council in May 1965. Although council members voiced concern about the number of floors planned for the new Bayshore Club Apartments (later renamed Bay Terrace), a review of the city ordinance revealed "that a 75-foot height limit and not the number of floors is the controlling item," noted a report in the *Collier County News*. Plans for the proposed 74-foot, eight-inch high structure included 30 units, a penthouse, and housing for air-conditioning equipment on top of the building. In this west-facing photograph, taken in 1969, the controversial building is visible in the lower center, next to the Naples Yacht Club. In the center, along Twelfth Avenue South, are the Village Green apartments. According to a January 1966 advertisement in the *Naples Guide*, "$44.00 a month buys a lot of comfortable, carefree living in this fine co-op."

Seven

COMING OF AGE

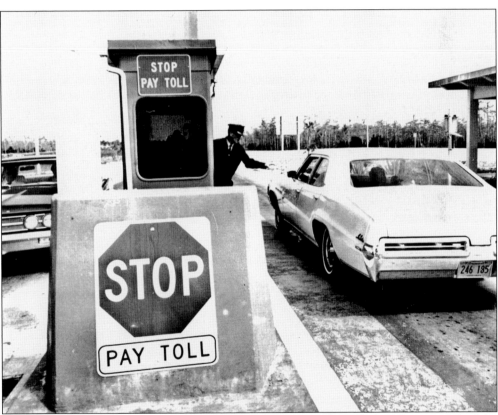

The controversial Everglades Expressway, contemptuously called "Alligator Alley" by the American Automobile Association, was officially dedicated on February 10, 1968. In honor of the road's colorful nickname, two live, well-trussed alligators attended the ribbon-cutting ceremony. A toll of 75¢ was collected at both ends of the new two-lane road that linked Naples to Fort Lauderdale. (Courtesy of the Florida State Archives.)

In 1946, the one-page Naples phone book listed 115 numbers. The small telephone building, located on Fifth Avenue South, housed a single operator, Mrs. Florence Booker, who retired in 1953, when the city acquired a dial system. According to a February 27, 1953, report in the *Collier County News*, "Naples telephone subscribers took the changeover to the dial system in stride last Wednesday evening. The first long distance calls were made by Mayor Roy Smith and City Manager Fred Lowdermilk. Operators will not be required and employees toured and observed the complex mechanism which will replace 'Number, please.'" The dial system was housed in a new building constructed just to the east of the original office on Fifth Avenue South, and by 1966, a $1 million addition was planned, which included a bank of public phones and a "courtesy area."

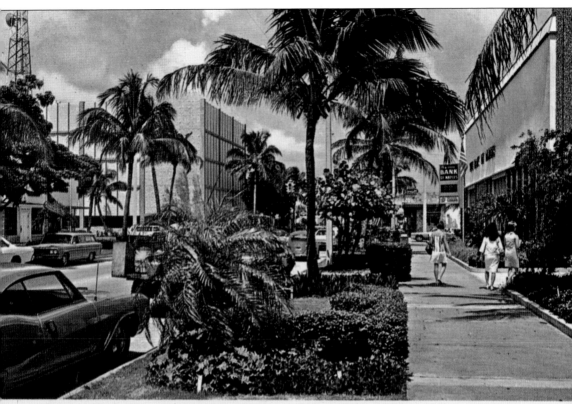

Fifth Avenue, Naples-On-The-Gulf, Florida

"Fifth Avenue South 'must' stroll for visitors," headlined the "Things to Do" section of the 1969 "Visitors Edition" of the *Collier County News*. In this special annual edition dedicated to visitors, a report noted, "Along the six-block route on Fifth Avenue South, from Third to Ninth Streets, one can buy anything from Ceylon sapphires to a Stilton cheese the size of a millstone. There's plenty of parking, with scores of parking meters all along Fifth Avenue where motorists may deposit a penny for 12 minutes or a nickel for two hours." This *c.* 1969 postcard features an east-facing view of the shopping area, just a block from Four Corners. In the distance, on the right, is the Rexall Drug Store, built by Victor Erday in 1951. Also on the right, in the foreground, is the Bank of Naples, which opened in 1949 and now included two floors, three drive-in windows, and its landmark time and temperature sign. In the distance, on the left, is the United Telephone Company building. (Courtesy of Nina Heald Webber.)

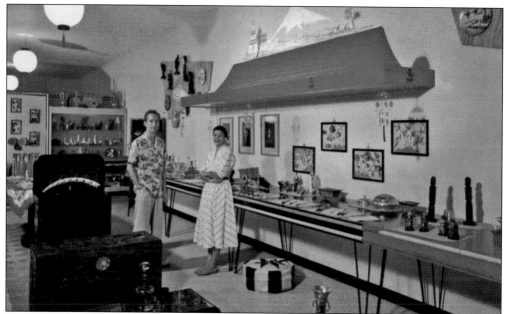

Ray and Ellen Christian opened their Fifth Avenue South gift shop, Internationally Yours, in the late 1950s. According to the caption on the back of this c. 1958 postcard, "After many years abroad, the Christians came to Naples and through the medium of friends that circle the globe, began to import unique and colorful craftwork from far away lands, for their unusual gift shop." (Courtesy of Nina Heald Webber.)

In 1959, Mary Helen Watkins began operating The Gallery at 353 Fifth Avenue South, offering "distinctive gifts," including Gattles linens, Rooster Craft ties, and "cocktail assortments." According to the January 1966 *Naples Guide*, "The Gallery is a veritable bazaar filled with imports, including fine English china and exceptional buys for everyday dishes and glasses. Mrs. Watkins also maintains a fine lending library and a marvelous selection of cards, bridge accessories, and is noted for her excellent gift wrapping." (Courtesy of Nina Heald Webber.)

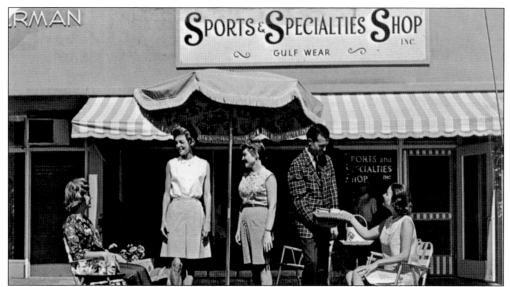

Robert "Rip" Frazer opened his Sports and Specialties Shop on Broad Avenue South, near the Third Street South shopping district, in 1961. Like most shop owners in Naples, he closed the store during the slow summer months. Posing in this c. 1964 postcard are, from left to right, Faye DeVogt, Dorothy Wood, Julie Yanson, Robert "Rip" Frazer, and Jan Gregory Frazer. (Courtesy of Jan Gregory Frazer.)

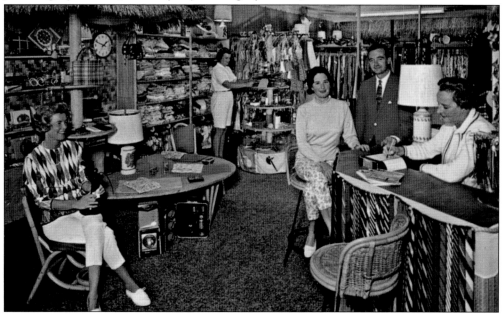

In 1965, Robert "Rip" Frazer moved his Sports and Specialties Shop from Broad Avenue South to Fifth Avenue South. A year later, he experimented with staying open year-round but returned to closing during the summer in 1967 since "there were very few people here during the summer," recalled his wife, Jan Gregory Frazer. This promotional postcard, mailed on April 1, 1968, announced a storewide seasonal sale. Pictured from left to right are Dorothy Wood, Justine Wakelee, Jan Gregory Frazer, Robert "Rip" Frazer, and Anne Dimeling. (Courtesy of Nina Heald Webber.)

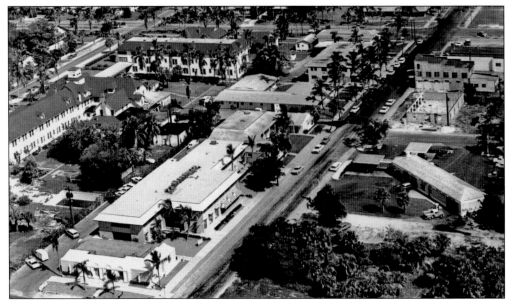

"Everywhere you look, there's something new," headlined the front page of the February 3, 1964, edition of the *Collier County News*. The report continued, "It is hard to go down any street in the Naples area and not see something being built." Above, the Chlumsky Building is under construction on the northeast corner of Twelfth Avenue South in this *c.* 1963 aerial view of Third Street South. The main building of the Naples Hotel, visible on the far left, was demolished in February 1964.

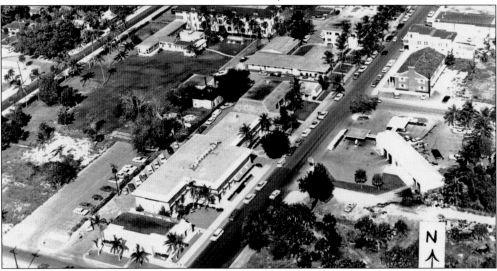

The grass-covered site of the recently demolished Naples Hotel building is visible on the left in this *c.* 1964 aerial of Third Street South. According to the caption for this undated *Collier County News* photograph, "Third Street South could be called the art center of Naples, housing as it does the R. and R. Robinson Gallery at the corner of 13th Ave. S. and Third Street South; The Harmon Gallery in the Fleischmann Central Building to the right of it, and farther up the street, the McNichols Art Gallery." A 1968 gallery listing noted that the R. and R. Robinson Gallery was "copied from the seventeenth-century Italian villa of Andrea Palladio."

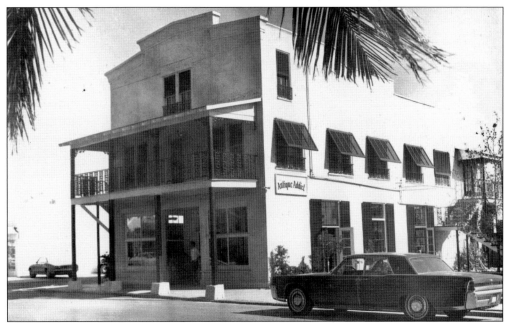

In 1951, philanthropist and entrepreneur Julius "Junkie" Fleischmann formed Neapolitan Enterprises and began several development projects on Third Street South. By 1961, he had converted the oldest commercial building in Naples, built in 1919, into the Antique Addict. According to a report in the 1968 "Visitors Edition" of the *Collier County News*, "Formerly known as the Old Seminole Market, it has been artistically restored. Sculpture, pop art and op art are found here, and many are very 'far out.' " Below, a late-1970s postcard shows the new Corner Building to the left of the Antique Addict, on the site of the landmark Beach Store and Quonset hut theater. The store and theater were torn down in 1974. (Below courtesy of Nina Heald Webber.)

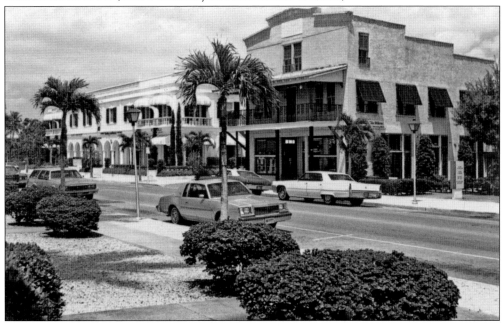

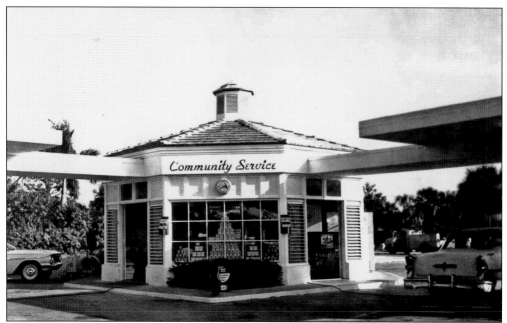

In 1960, there were 23 gas stations listed in the Naples telephone book, including the Community Service Station, pictured above, located on the southeast corner of Third Street South and Twelfth Avenue South. Three years later, the Crayton Cove Standard Service station opened just down the street, on the corner of Twelfth Avenue South and Eighth Street South, adjacent to the new Cove Inn complex. According to the caption on the back of the c. 1964 postcard below, the Crayton Cove station offered "Wash and polish, free pickup and delivery. Experienced attendants. Adjacent to City Pier and Sports Spot Marina. Bob Adams, Manager." (Below courtesy of Nina Heald Webber.)

By 1966, the historic Naples Company building, constructed c. 1921 on the southwest corner of Broad Avenue South and Third Street South, had been converted into the Locker, a nautical gifts and accessories store. According to an advertisement in the January 1966 *Naples Guide*, the new store offered, "Unusual and unique nautical items. It's a new kind of look in Naples. Located in the old Collier County Library building." In 1970, Carl and Gretchen Hedin opened their Colonial Cheese and Gourmet Shop in the building. The caption on the back of the c. 1971 postcard below noted, "Cheese cut from wheels from every part of the world. Early American gifts, scrimshaw, old butter mould pattern products, cheese boards and knives." (Courtesy of Nina Heald Webber.)

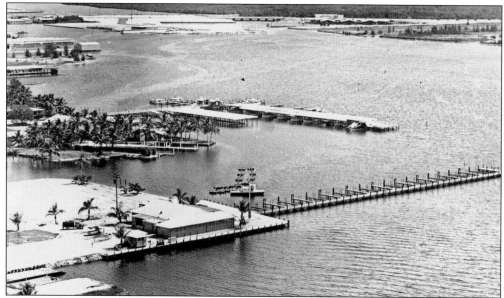

Three influential Neapolitans, Benny Morris, Glen Sample, and Stephen Briggs, formed the Naples Yacht Club in 1959; Briggs, one of the founders of the Briggs and Stratton Motor Company, became the first commodore. The new yacht club building and docks are visible in the lower center of this c. 1960 photograph. To the left of the yacht club are the covered city dock slips. Just to the north of the City Dock is the vacant, still-submerged site of the Cove Inn.

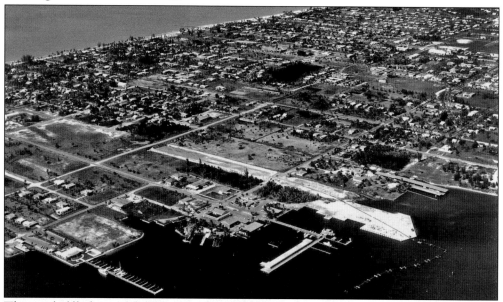

The newly filled site of the Cove Inn is visible on the lower right center of this photograph dated January 22, 1963. Plans for the million-dollar motel and marina complex were announced in August 1961, and by June 1963, pilings were being driven "15 feet into the ground to guarantee a firm foundation for the three-story bayfront motel," noted a report in the *Collier County News*. Plans also called for the extension of Broad Avenue South and the construction of a convention hall, shops, and bar.

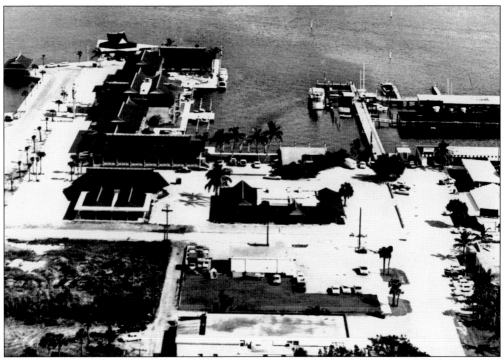

According to a May 1963 report in the *Collier County News,* "The new Cove Inn should be ready by January 15, 1964. Room reservations dating from February 1, 1964 are now being taken." In addition to 116 rooms and 75 "yacht-el" boat slips, the new complex included a restaurant, the Hut, situated directly on the bay. The bar and restaurant served an exotic Polynesian menu in keeping with the "Neapolynesian" style of the Cove Inn complex. In 1968, the restaurant was renamed Marker 4, after the channel marker visible just outside its windows. To the left of the restaurant, visible in the upper left, is the nearly complete U.S. Coast Guard Auxiliary building. At the bottom of the photograph is the Crayton Cove Standard Service Station. (Below courtesy of Nina Heald Webber.)

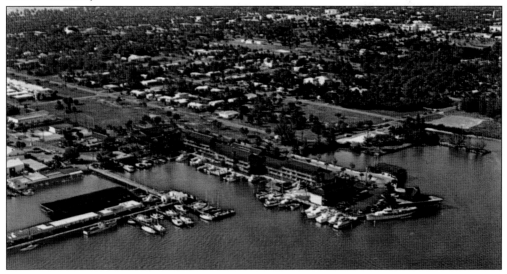

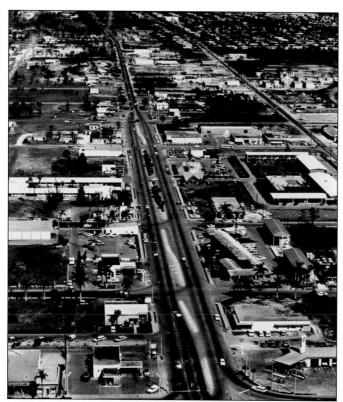

By 1960, the population of Naples had increased to 4,655, although a chamber of commerce publication, "Consider Naples First," estimated the winter season population to be "10,000-plus as a result of the tourist industry." Visitor-related businesses, including motels, hotels, restaurants, and gas stations clustered along the increasingly busy Tamiami Trail, still the main gateway into Naples. In this north-facing, late-1960s photograph, Four Corners is visible in the lower center. The angled building in the center is the Trail's End Motel. The road narrowed to two lanes near Central Avenue.

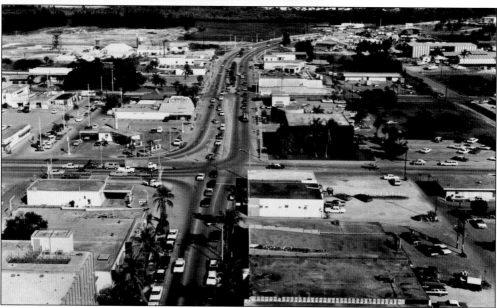

This east-facing view of Four Corners, dated 1969, shows the palm-lined shopping district of Fifth Avenue South in the foreground. Two gasoline stations, Naples Liquors, and the two-story Naples Federal Savings and Loan anchored the Four Corners. The Lamplighter Restaurant, the city's first cafeteria, is visible behind the Gulf station. The United Telephone building is visible at the lower left.

In 1959, a report in the *Collier County News* noted: "The eastern entrance to Naples is undergoing drastic changes for the better. Four-laning of the Tamiami Trail, which runs through Naples proper, is almost complete." Right, a *c.* 1970 east-facing view of the road shows the busy intersection with Davis Boulevard in the center. Just below the intersection is the Boat Haven marine complex, built on fill "pumped from the bay and river bottoms to make new high land where once stood nothing but unattractive growth and clutter," noted a report in the October 29, 1959, issue of the *Collier County News.* Below, an advertisement for Boat Haven was featured in the 1970 Naples High School yearbook. (Below courtesy of Nancy Evans.)

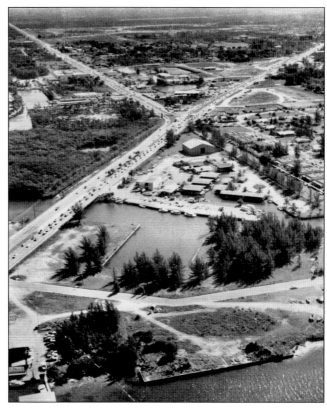

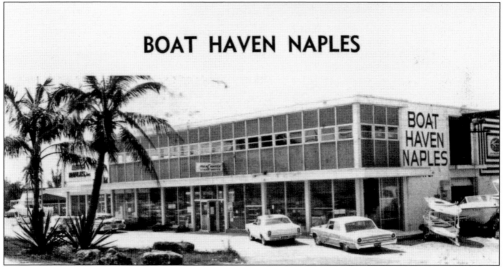

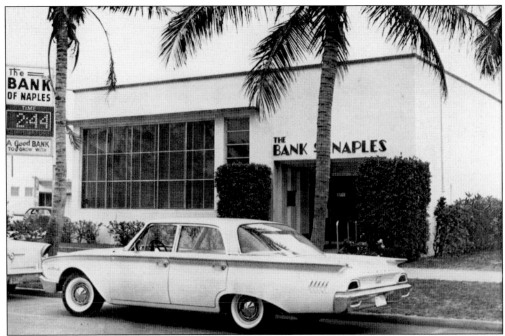

In 1949, two momentous events occurred in Naples—the town became a city, and the first bank, the Bank of Naples, opened for business. The first, 2,814-square-foot bank building was constructed on the southwestern corner of Fifth Avenue South and Eighth Street South. By 1963, the building featured a "time and temperature" sign, visible above in this 1963 advertisement from the Naples High School yearbook. Five years later, the building had been enlarged and included a second floor, parking lot, and three drive-in windows. The Bank of Naples merged with Barnett Bank in 1975. (Above courtesy of Gerry Johnson; Below courtesy of Nina Heald Webber.)

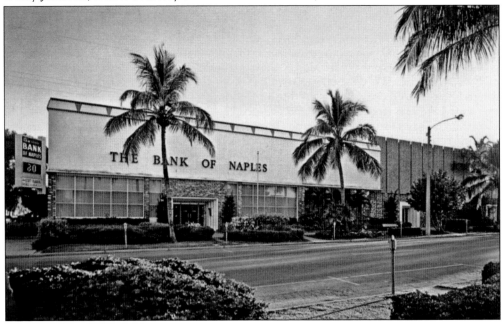

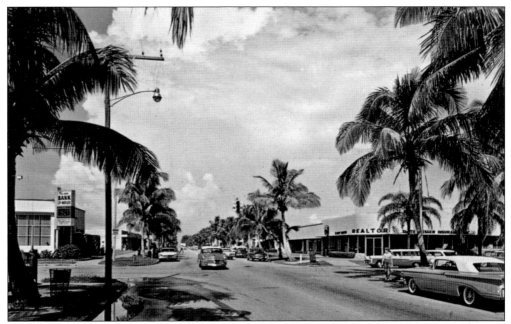

Sixty-one real estate offices were listed in the 1963 Naples phone book, including former mayor Roy Smith's office, visible above on the right in this early-1960s postcard of Fifth Avenue South. Across the street is the Bank of Naples. In 1966, R. H. "Dick" Goodlette, a county commissioner from 1956 to 1961, opened a real estate office with partner E. Virgil Marcum on the north Tamiami Trail, right next to the Dairy Queen, which opened in 1964. A report in the March 9, 1969, edition of the *Collier County News* noted: "Collier County's gigantic realty boom shows little signs of subsiding. Another huge week was chalked up for the last week in February, with total sales hitting $3,682,990." (Courtesy of Nina Heald Webber.)

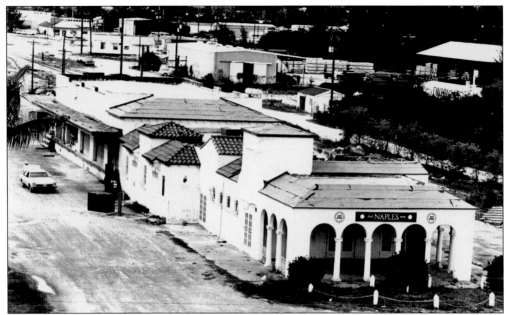

Seaboard Airline Railway's *Orange Blossom Special* steamed into the not-quite-finished Naples Depot on January 7, 1927. Fifteen years later, the railroad company stopped service to Naples and sold most of its holdings to the Atlantic Coast Line Railroad. During World War II, the vacant building was used as a USO-type club for soldiers stationed at the Naples Airdrome (now Naples Airport). In December 1952, the Atlantic Coast Line launched its new air-conditioned Pullman service to Naples with *The Champion*, and Mayor Roy Smith expressed appreciation to the ACL officials, noting the Seaboard Railroad had "decided the Naples area showed no promise." The last passenger train pulled out of the Naples Depot on April 21, 1971. Freight service continued until 1980.

"New Site Picked for Post Office," was the front-page headline of the December 18, 1956, edition of the *Collier County News*. Despite concerns that the site, located on the southwest corner of Third Avenue South and the Tamiami Trail, was too close to schools and would increase traffic in an already congested area, construction of the $50,000 building began in January 1957. Just three months later, the new post office opened on Wednesday, May 1, 1957, at 9 a.m., 10 days ahead of schedule. The new, 5,000-square-foot building offered air-conditioning and 24-hour access to private mailboxes, which were removed from the old building on Third Street South. The *Collier County News* covered the opening and reported, "The first customer Wednesday morning was Tommy Weeks, who bought a supply of envelopes."

Soon after the Florida Legislature created Collier County in May 1923, its namesake, Barron Gift Collier, started a newspaper to publish legal notices for the new 2,000-square-mile county. The first four-page issue of the weekly *Collier County News* debuted on July 25, 1923. Although the newspaper office was located in the county seat of Everglades, the paper was printed in Fort Myers. In 1947, the offices were moved to Naples. Editor Stuart Rabb's November 7, 1947, editorial noted, "With this issue, the Collier County News makes its residence in Naples official. In doing the job of covering the news in Naples and Collier County, the newspaper is depending on its readers to serve as reporters. Readers know the kind of items they like to see. Especially interesting are accounts of parties, visitors, visits, etc. Mail these items to the News or telephone us. The number is 23." Three years later, both the offices and printing equipment were moved into a building on Twelfth Avenue South, in Crayton Cove, pictured above. Publication increased to twice weekly, Tuesdays and Fridays, in October 1954.

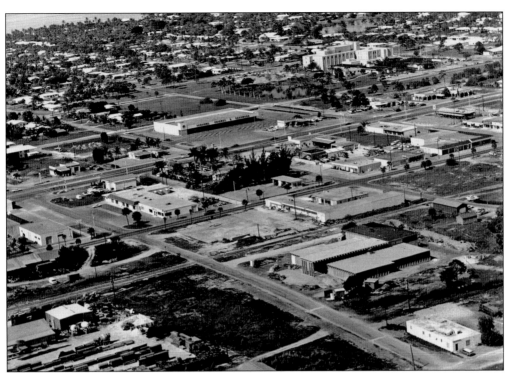

On February 24, 1968, the newspaper announced: "After 20 years in the Crayton Cove area, the Collier County Daily News will be moving to a new location in a matter of months. A site for a new building has been purchased on Central Avenue, just east of the Seaboard Coastline tracks. When the Daily News moved to its present location, it was published weekly and had a staff of six. Now, its published six days a week and has a staff of over 60." The newspaper moved to the new, 10,000-square-foot building in 1969, and the name was changed to the *Naples Daily News*. Above, the new *Naples Daily News* building, under construction, is visible in the lower right, just to the right of the railroad tracks in this *c.* 1969 photograph. Below, paper carriers pose in front of the *Naples Daily News* street sign, *c.* 1975.

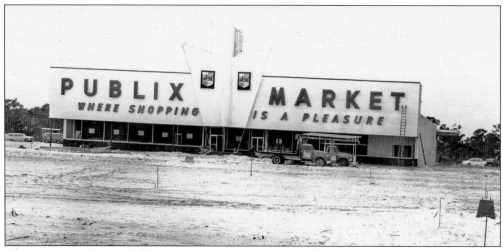

The opening of a new Publix grocery store on the north Trail in the Moorings subdivision "marks another milestone in the business expansion of Naples," noted a front-page article in the January 21, 1962, edition of the *Collier County News*. The article continued: "This will be the 75th unit to be opened by the chain. Presently, it is the first and only business firm in the new Naples Shopping Center, destined to expand along with the population growth of the Naples area." The new store opened on February 1, 1962, and featured six check-out stations. A cannon was fired as Mayor Francis Ford officially cut the ribbon to open the store. Just a few years later, more stores were added, including Grants, visible below in this *c.* 1965 photograph. Note the Tamiami Trail is still only two lanes wide at this time.

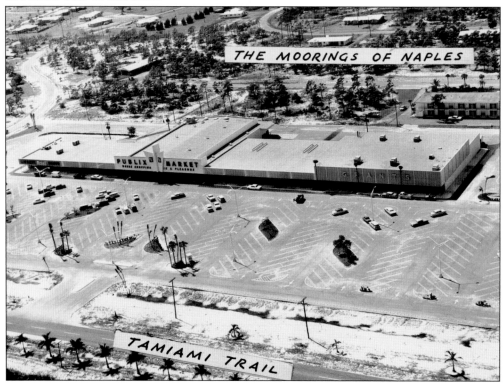

A new, $2-million addition to the Naples Community Hospital was dedicated on November 27, 1966. More than 500 people attended the ceremony and toured the new facilities, which included 50 new beds, new operating rooms, a surgical recovery room, and new dining and kitchen facilities. Interior design was again provided by Dorothy Draper, and the *Collier County News* noted, "The Draper blues and sea greens are much in evidence again in the soft tweedy nylon carpeting and luxurious drapes." Below, Miss Sylvia Schmid, radiology technician, poses with new, state-of-the-art equipment, *c.* 1975.

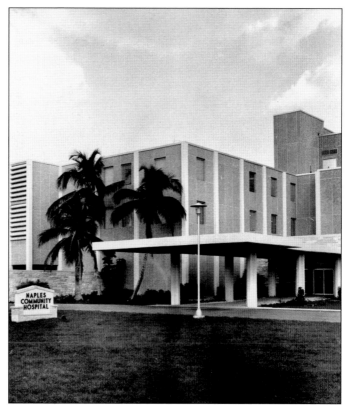

The Tamiami Trail opened in 1928 and became a vital gateway into Naples. It was expanded to four lanes through the city center in 1959, and in March 1966, an article in the *Collier County News* announced "additional four-laning of the north Trail, for a distance of four miles is about to begin." More miles were added to the project, and by November 1970, the *News* noted, "Ten more days is estimated for paving the 6.4-mile four-lane widening job." Just eight months earlier, the newspaper reported, "City Council learned their own misplaced water lines were much to blame for the delays and added costs for the $1 million street improvement project." Construction delays earned the ire of one homeowner, below, who put a sign in the yard asking, "Dear City! When?"

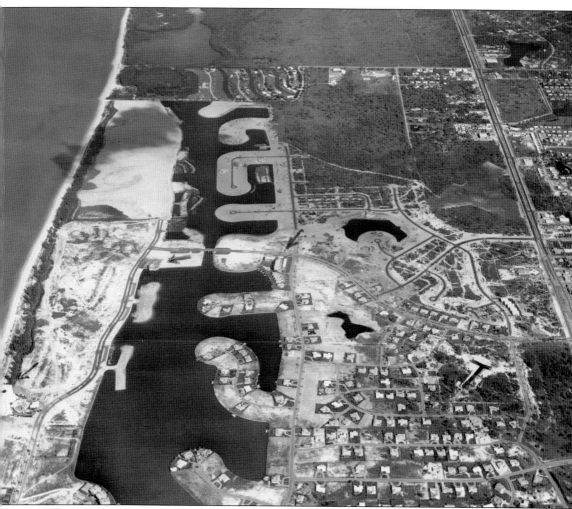

Small arrows were drawn onto this February 3, 1971, aerial of Park Shore, indicating the Horizon House high-rise building on the lower left; the Park Shore office, visible to the left of the bridge, near the center of the photograph; and the Colony Gardens and Villas, in the center. Raymond L. Lutgert bought the 772-acre property for $3.5 million in 1964, and by 1968, his multi-million-dollar Park Shore subdivision, located just north of the Moorings, was underway. In addition to single-family home sites, many on the water, the property included one-and-a-quarter miles of beachfront, reserved for luxury high-rise condominiums. By 1979, high-rises crowded the beachfront, and the area was dubbed "Condominium Row."

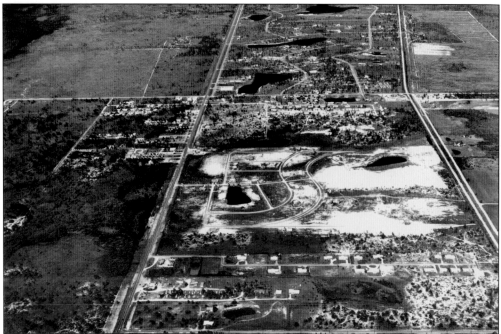

Just north of Park Shore, one of the last large tracts of undeveloped beachfront property was acquired in 1972 by the newly formed Coral Ridge–Collier Properties, Inc., development company. The 2,104-acre parcel, called Pelican Bay, became one of the first large-scale developments in Florida to be designed according to new state environmental laws created to protect sensitive ecosystems. Above, a January 22, 1963, aerial shows the undeveloped site of Pelican Bay at the upper left, bordered on the right by the Tamiami Trail. Below, Ross Obley (second from left), president of Coral Ridge–Collier Properties, Inc., shakes hands with an unidentified man in this *c.* 1978 photograph, perhaps at the start of the development of Phase 1, which began in September 1978.

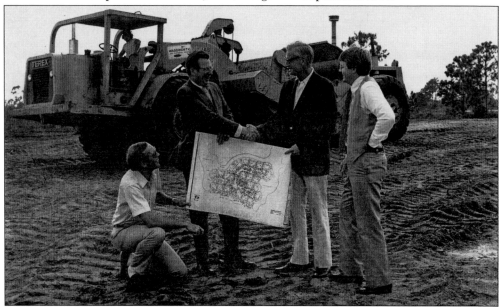